WORK

THE WORLD IN PHOTOGRAPHS

FAKE IT
Self-tan lotion

THE BODY SHOP

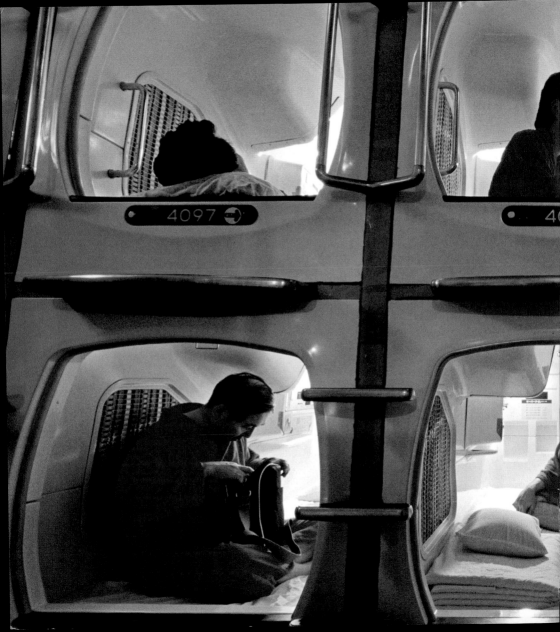

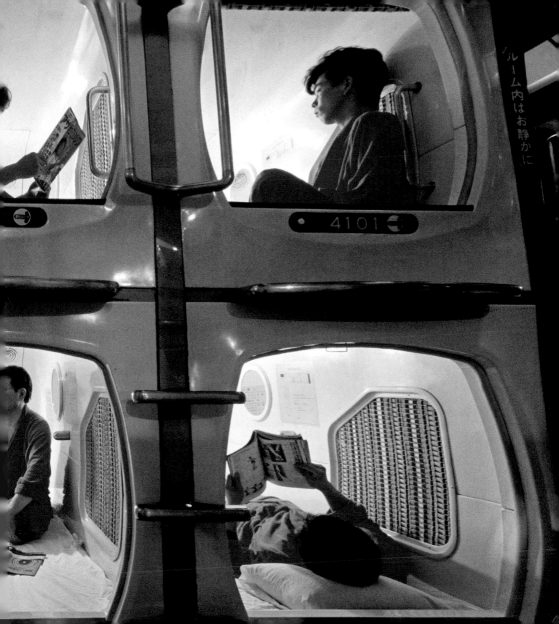

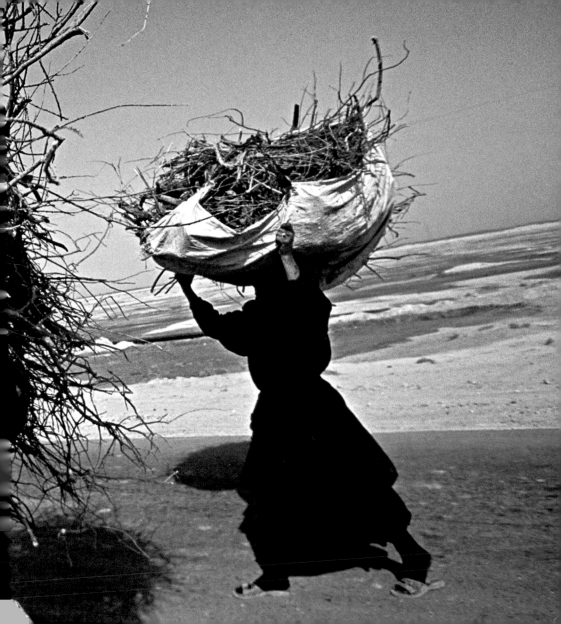

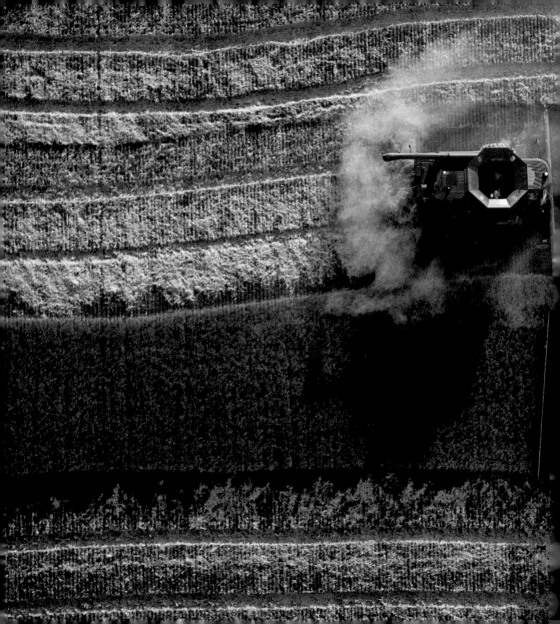

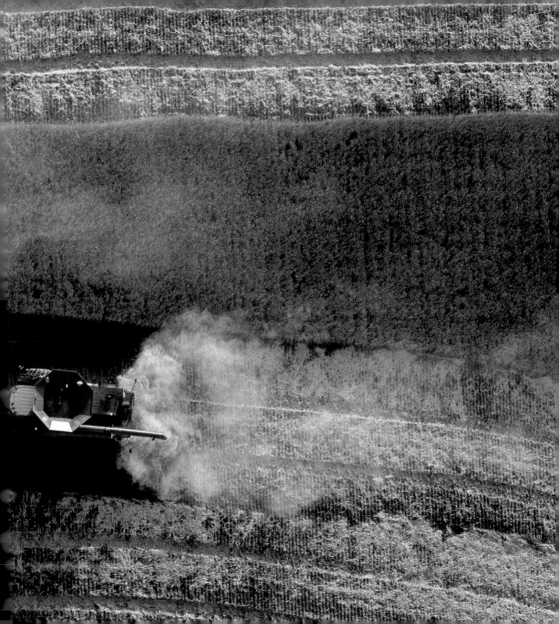

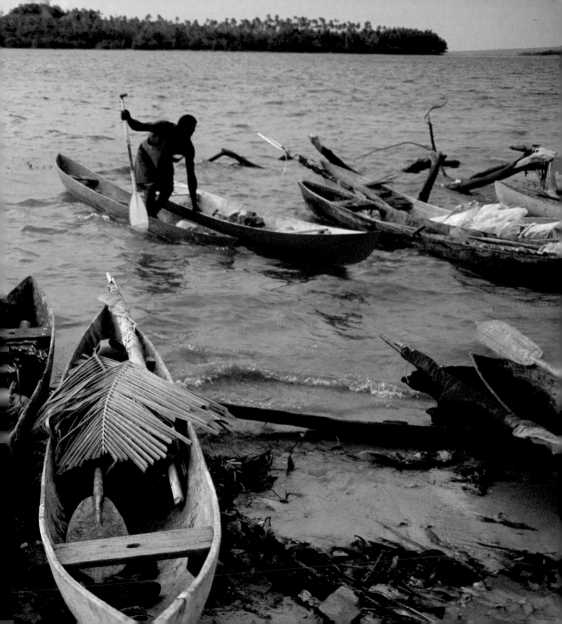

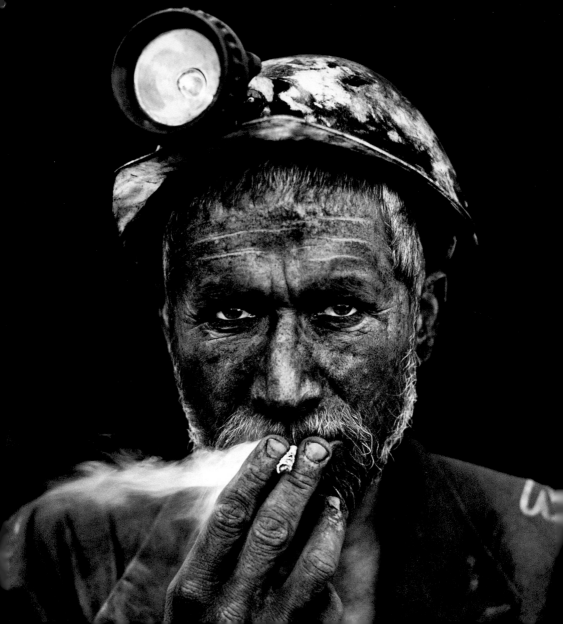

WORK

THE WORLD IN PHOTOGRAPHS

Ferdinand Protzman

NATIONAL GEOGRAPHIC

WASHINGTON, D.C.

Contents

foreword

"*Speak with your images from your heart and soul. Give of yourselves. Trust your gut reactions. Suck out the juices—the essence of your life experiences. Get on with it; it may not be too late,*" —Marion Post Wolcott

"*As photographers, we turn our attention to the familiarities of which we are a part. So turning, we in our work can speak more than of our subject—we can speak with them; we can more than speak about our subjects—we can speak for them. They, given tongue, will be able to speak with and for us. And in this language will be proposed to the lens that with which, in the end, photography must be concerned—time, and place, and the works of man.*" —Dorothea Lange.

The works and work of mankind won't fit in any single book or in all the libraries in the world. We're surrounded by them. Every minute of every day, new ones are being created, old ones destroyed. There are countless jobs and billions of people doing them every day. These photographs of people working at various jobs, in various times and places around the world, don't begin to scratch the surface of man's works or working.

This isn't an encyclopedia or a typology. These photographs were selected because they have something to say about time, place, and people. When we talk about work, we're really talking about vast networks of individuals working together. Even though each person does his or her own work, it is almost always in the context of some larger unit, a family, a clan, a tribe, a company, a university, or an organization. Very few people actually work alone.

When work is turned into a photograph, it changes. The Afghan coal miner staring at you from the title page is transformed from a living, breathing, three-dimensional person, weary, dirty, and savoring a cigarette, into a flat picture. The coal dust covering his skin, and coating his lungs, becomes a color and a texture instead of a health hazard. His gaze, which might be unsettling if you were standing face-to-face, is magnetic and benign. Miner and mining become art.

That may seem like a paradox, but it isn't. How work looks is different from the way work is, or how the people doing the work feel and think about it. Looking at pictures of work can evoke thoughts and feelings about work and life. Good art does that, whether it's photography, painting, music, dance, film, or literature. It leads each of us to ponder in our own, personal terms, not just the subject at hand but the universal nature of human existence.

That is not an abstract, philosophical exercise. The photographers in this book show us the world of work as it really is. Or— in some pictures—was. Their motivations and methods varied. Some, like Lewis Hine, were out to expose social inequalities, such as the evil of child labor in the United States in the early 20th century. Edward Curtis set himself the task of documenting Native American ways of life that were rapidly vanishing. Contemporary artists like Edward Burtynsky and Sebastião Salgado explore the ambiguous relationship between industry and man and the migration of workers around the world.

In all the pictures there is that sense of dialogue between the subject and the artist that Dorothea Lange wrote about. There's more, as well. With photos presented in a book, rather than on a wall in some museum or gallery, that dialogue expands into an ongoing conversation between the readers, the artists, and their subjects.

Photographs aren't tape recordings. They don't directly transmit the sounds of work: the metallic

staccato of a jackhammer, the swish of a mop, or the bellow of a construction foreman. They don't play back the voices and words of the people you see here. Yet, these photos, by artists past and present, speak to our hearts, our minds, and our guts in the international visual language of pictures.

They tell of their subjects' work and lives and circumstances. The pictures speak of wealth and poverty, pain and violence, joy and sorrow. We see the dignity, despair, courage, and perseverance of those depicted. In this great conversation, we learn how much all human beings have in common and how little it can take to set us against each other.

The photos look beautiful. Their shapes and colors, their vistas and faces are beguiling. But beauty, tragedy, and horror aren't mutually exclusive. The photographers who worked so hard to make these pictures understand that what they view can be gorgeous, transfixing, and horrible.

Work has no conscience, memory, or morals. Human beings do, at least some of them, sometimes. Looking at the picture of the boy sitting in a pile of carbon in Bangladesh, earning a pittance by tearing apart dry-cell batteries with a hammer and his fingers to recover the metals, I wonder whether the people who pay him ever worry about his health and well-being. Is he a person to them or just a replaceable part in their business, a human power source to be used up and discarded?

That's how work is in many places, an existential struggle in which people do whatever they must to keep themselves and their families alive. Self-fulfillment of the sort that Marx or Freud believed could be attained through work isn't a factor in many people's lives and certainly isn't evident in the photo of a Dinka woman stewing leaves for supper in Sudan. Survival is her work. She didn't choose that occupation. It was forced upon her by sectarian conflict.

All work isn't drudgery or misery, of course. Some people find their work fulfilling. Some flat out love their jobs. They're the lucky ones. There is also a social aspect to work. People make friends on the job; they share happiness, as well as problems. Funny things happen. Sometimes folks laugh or sing at work. Other times they get into disputes with bosses and co-workers. They quit and someone else gets hired. That's the way life works.

If you look closely, all that can be seen in these pictures of work around the world, pictures taken by photographers speaking from their hearts and souls. Looking is the key. As Walker Evans once wrote, "Stare. It's the way to educate your eyes. Stare. Pry, listen, eavesdrop. Die knowing something. You are not here long."

— Ferdinand Protzman

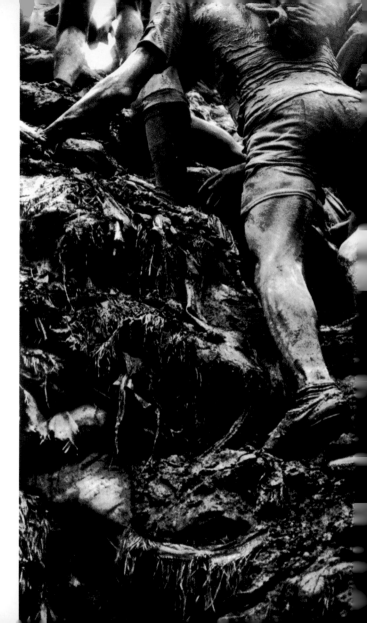

SEBASTIÃO SALGADO
Gold miners carrying soil
from pit, Serra Pelada, Brazil
1986

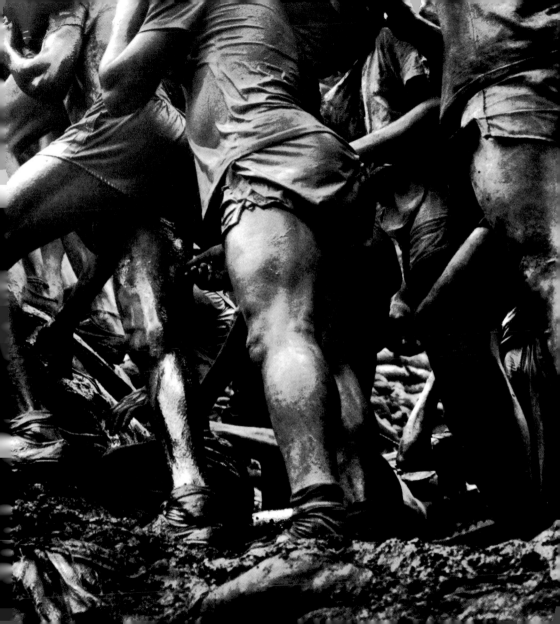

europe

O n a chilly spring day in Maramures, two old women sit together on a bench in front of a farmstead's wooden gate. They are wearing woolen garments typical of the remote, mountainous region, hard by Romania's northern border with the Ukraine. One woman, sporting a brightly patterned apron of blue and white, gazes down the lane. The other's eyes are fixed on the yarn she is spinning by hand from a bundle of new wool, the size and shape of a folded beach umbrella, fastened to a wooden stick held between her legs. The fingers of her left hand control the twist and diameter of the yarn with a violin virtuoso's touch. A spindle dangles from her right hand, which has pulled an arrow-straight length of yarn from the wool. It's a graceful piece of work, repeated countless times over the years, and a serene moment, frozen in Alexandra Avakian's beautiful photograph.

The spinning didn't stop because Avakian was taking a picture. By the time she lowered the camera that day in 1998, the women moved, more freshly spun yarn was drawn and wound onto that spindle, the light shifted, and time ticked on. The women weren't posing or demonstrating some ancient handicraft for a curious visitor. They were just ordinary people doing ordinary things, sitting by the gate, spinning yarn the same way generations of women in Maramures have since the Dacian tribes inhabited the region in 1000 B.C. Spinning wool wasn't an end in itself but part of a way of life in an ancient, agrarian culture that has survived invasions by the Tartars and, more recently, decades of Communist rule that destroyed many Romanian farms and villages through forced collectivization. Once the woman completed her spinning, other work was waiting to be done. It always is, in Maramures and around the world.

Work never stops. It is a common human endeavor that began with the ascent of man and is now omnipresent on Earth and extends into space. Every major religion begins with the idea of a Supreme Being working to create the world, as in the Bible's Book of Genesis, "Thus the heavens and the earth were finished, and all the host of them. And on the seventh day God finished his work which he had done, and he rested on the seventh day from all his work which he had done." Every economic and political system is based on work, collective and individual. Every person in our global population of more than six billion works in some sense of the word, beginning with the work and sensations mother and child share in gestation, labor, and birth and continuing with the task of survival.

The word "work" is a world unto itself—a verb, a noun, a metaphor, an idea, a process, a product, a sound, a deed, a pain, a pleasure, a baby drawing its first breath in Beijing, a guardsman standing watch at Buckingham Palace, an Indian worker operating a power loom in a silk factory, a Kenyan ranger patrolling a game preserve, a farmer plowing a stony field in the Andes, or an old Romanian farm woman spinning wool.

Even in a traditional, rural society, such as Maramures, every sense of the word is present. The most visible work, the kind a person traveling around the region sees, has changed little over the centuries. It centers, as most work ultimately does, on filling people's basic needs for food, clothing, and shelter. Buildings in Maramures are constructed from wood cut from the abundant forests, which also provide fuel for heating and cooking. Animals are tended and slaughtered, crops planted and harvested. Sheep are sheared, wool is spun and made into garments. Some of these tasks are shared by men, women, and children, others divvied up along traditional gender and age lines. Local tradition dictates that men be skilled at woodcarving, women at spinning, dying, weaving, and sewing.

To an urban sophisticate working in Paris, New York, Tokyo, or Rio de Janeiro, the life and work in Maramures may seem like unrelenting drudgery, an existence grubbed from the land that perpetuates a hidebound, sexist society. Other city dwellers may find it alluring and romantic, a simpler, healthier way of working and living, closer to family, neighbors, and nature. Rural Romanians, on the other hand, may dream of living in a big city, or loathe the thought.

Each of us sees the work of others through the lens of our own work, beliefs, and culture. The same holds true for the way we see pictures of work. Avakian's photograph, as well as the others in this book, can be viewed aesthetically. Her picture of the two women is a thing of beauty, a medley of contrasting and complementary colors and textures that draws the eye to the women's weathered faces and strong hands. To someone steeped in Western art, it combines the body language from Michelangelo's "Pieta" with the lyrical economy of Käthe Kollwitz's etched self-portraits and the psychological presence of Rembrandt's figure paintings.

That's a great accomplishment for any picture, and if all one ever does is savor its beauty, that's fine. But this isn't a sculpture, print, or painting. It's a photograph of two women, a place, an action, and a moment in time that Alexandra Avakian saw and excerpted from life in the blink of a shutter. Because it comes directly from life, her photograph, like all truly great photos, has an immediacy and a power to communicate that goes beyond its aesthetic appeal. By showing us how life, work, and two women looked one day in a remote part of Europe, Avakian tells us something about that place and its people, about what they do and how they look. Beyond that, she opens the way for us to consider or reconsider our own ideas about life, people, and work.

There is no single story that encompasses the world of work, no tidy narrative with a beginning, middle, and end. Work is an integral part of life, and work's global story is an immense epic constantly being woven from billions of individual tales, each passing through its own stages of development, spanning the range of human experience. In that epic, work can be place and time, life or death, fun or torture. Work is what we do and often who we are. As you read this, someone, somewhere is working. Maybe you.

Like Avakian's picture, the photographs in this book are excerpts from that vast pool of stories. Each photograph is a string of yarn that winds through that epic, a story line told in the international visual language of pictures. Like every good story, these images can evoke feelings and thoughts in those who look at them, establishing a living connection between the subject, the medium, the artist, and the viewer. For a moment, the people, places, and things we see in these pages become part of our lives, our stories, our worlds of work.

There are, of course, things photos do not tell us, at least not in words. They don't convey how the people depicted in these pictures feel about the work they are doing, the place where they are working, or their co-workers. We don't directly hear the subjects' voices and thoughts as one does in Studs Terkel's remarkable book *Working*. Nor do we hear firsthand the sounds of work—the roar of sulfur pouring into a Sicilian warehouse, the cacophony of an auto plant.

Yet, even at a remove, these pictures communicate forcefully, in a manner best described in a lecture in 1909 by Lewis Wickes Hine, whose photographs of children at work helped get the practice of child labor banned in the United States.

"Whether it be a painting or a photograph, the picture is a symbol that brings one immediately into close touch with reality. It speaks a language learned

early in the race and in the individual—witness the ancient picture writers and the child of today absorbed in his picture book. For us older children, the picture continues to tell a story packed into the most condensed and vital form. In fact, it is often more effective than the reality would have been, because, in the picture, the nonessential and conflicting interests have been eliminated. The picture is the language of all nationalities and all ages. The increase, during recent years, of illustrations in newspapers, books, exhibits, and the like gives ample evidence of this.

"The photograph has an added realism of its own; it has an inherent attraction not found in other forms of illustration. For this reason the average person believes implicitly that the photograph cannot falsify. Of course, you and I know that this unbounded faith in the integrity of the photograph is rudely shaken, for, while photographs may not lie, liars may photograph. It becomes necessary, then, in our revelation of the truth, to see to it that the camera we depend upon contracts no bad habits."

Photography and the world have changed quite a bit since Hine's day. The "increase of illustrations" is now a relentlessly expanding torrent of photographs. Meanwhile, digital technology has severely eroded photography's evidentiary value. Photos can and do lie. Despite all that, Hine's statement remains valid. Some artists and documentarians, such as those featured here, still seek to reveal the truth. The advances in the production and dissemination of photographs have only helped them in their quests.

The visions of work presented in this book have been shaped in large measure by Europe. Photography was invented there and from its infancy in the 19th century, the medium was part of the Western aesthetic that has come to dominate the world, a status initially achieved through photomechanical reproduction and expanded of late by computers and the Internet.

Europe is also where the world's prevailing ideas about work's value, organization, and meaning were formed. Work's power to shape the world and people's lives was already being extolled in ancient times. Aristotle asserted that pleasure in the job put perfection in the work, but took a dim view of work for pay, writing that "all paid jobs absorb and degrade the mind."

During the time of Augustus Caesar, the Roman poet Virgil coined the Latin phrase, "labor omnia vincit," or "work conquers everything," in a poem in four books called the *Georgics*. Although history has since provided ample evidence of things impervious to work's power, illness being an example, that phrase remains quite popular, serving as the motto of several cities in Britain, the American Federation of Labor, the state of Oklahoma, and workaholics everywhere.

The modern world's ideas and images of work were shaped by European events, thinkers, and artists. By the 18th century, advances across Europe in science and agriculture were clearing the ground for the Industrial Revolution, in which machinery driven by water or steam power transformed manufacturing into a mass enterprise employing large numbers of workers and producing large quantities of goods. Attracted by the lure of industrial jobs, people moved in droves from the countryside to the cities, a process still going on in parts of the world.

For visual artists, the Industrial Revolution provided a host of new subjects: steam engines, railroads, steel mills, and bustling cities. These were depicted in the 19th century by such luminaries as J. W. M. Turner, Claude Monet, and Adolph Menzel. Their pictures explored the new ways and means of work from an aesthetic, rather than social or political perspective.

Those aspects of life in mass, industrialized society would be analyzed by other Europeans including two of the most influential thinkers on the subject of work: Sigmund Freud and Karl Marx. To Freud, love and work, "lieben und arbeiten," were the two driving forces in human life. As he wrote in 1930, in *Civilization and Its Discontents*, "No other technique for the conduct of life attaches the individual so firmly to reality as laying emphasis on work; for his work at least gives him a secure place in a portion of reality, in the human community. The possibility it offers of displacing a large amount of libidinal components, whether narcissistic, aggressive or even erotic, on to professional work and on to the human relations connected with it lends it a value by no means second to what it enjoys as something indispensable to the preservation and justification of existence in society."

Despite that value, Freud wrote, "as a path to happiness, work is not highly prized by men. They do not strive after it as they do after other possibilities of satisfaction. The great majority of people only work under the stress of necessity, and this natural human aversion to work raises most difficult social problems."

Marx believed work was the most important aspect of a person's life, potentially the most fulfilling, and that industry represented the essential powers of man, man's psychology and creativity given tangible form. The chief social problem tied to work was, in his view, capitalism. This made man a wage-slave, alienating him from his true creative self, leaving him unfulfilled. His solution was Communism, which he boiled down to the dictum, "from each according to his ability; to each according to his need."

Regardless of what one thinks of Freud's or Marx's ideas, their thoughts have had dramatic effects, for good and ill, on the world and remain powerful and controversial today. It's worth noting that while both men worked hard and produced prodigious quantities of writing on work-related subjects, neither had much direct experience of manual labor or many other forms of work. There is no evidence, for instance, that either man ever spun wool by hand, slaughtered a hog on a cold December day, built an automobile, loaded a barge with rape seed, trained to be a ballet dancer, or stood guard at Buckingham Palace.

In this chapter, we see men, women, and children doing those things. Some of them may be alienated from their work or using it as an outlet for their libidos, but not all. People do work to fill their needs for food, clothing, and shelter and many people hate their jobs. But others do not. The young ballerinas, the bullfighter in Spain, or the member of the Life Guards of the Household Division at Buckingham Palace photographed by Jodi Cobb aren't just out for paychecks. They chose what they are doing.

Take the Guardsman. His image calls to mind "The Man with the Golden Helmet," painted by Rembrandt circa 1650, and hanging in Berlin's Picture Gallery. Like that painting, believed by some experts to represent Mars, the god of war, the Guardsman is a symbol. He is a highly trained soldier, but his work is to represent the traditions, strength, and endurance of the British monarchy. While his gleaming helmet may conjure images of sabers flashing on battlefields around the world, he is actually ill-equipped to protect the Royal family in an era of suicide bombers and high-tech weaponry. Like the woman spinning in Maramures, his eyes are fixed on his work. In the photograph, his resolution will stay that way, no matter what Sigmund or Karl or anyone else might say.

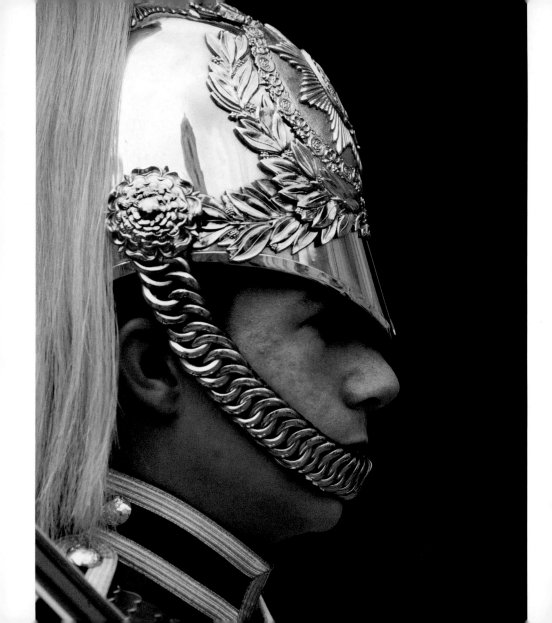

preceding pages:

JOE MCNALLY
Ice fishermen heading home, Lavozero, Russia
2000

JODI COBB
Standing guard at Buckingham Palace, London
1999

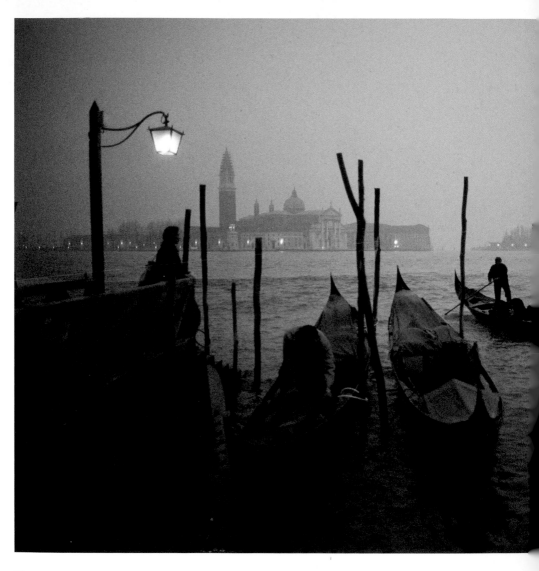

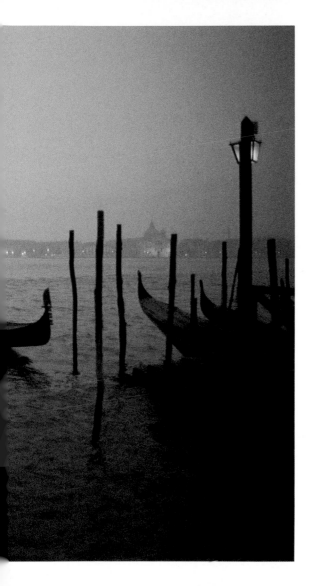

SAM ABELL
Gondoliers mooring their boats for the night,
Venice, Italy
1994

GERD LUDWIG
Drinking schnapps after slaughtering a hog, Germany
1977

opposite:

GUGHI FASSINO
Workers at the Zastava auto plant, Kragujevak, Serbia and Montenegro
2005

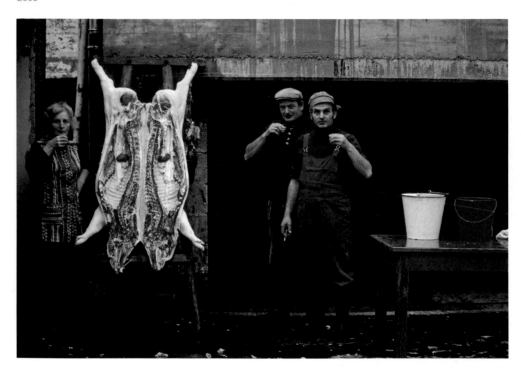

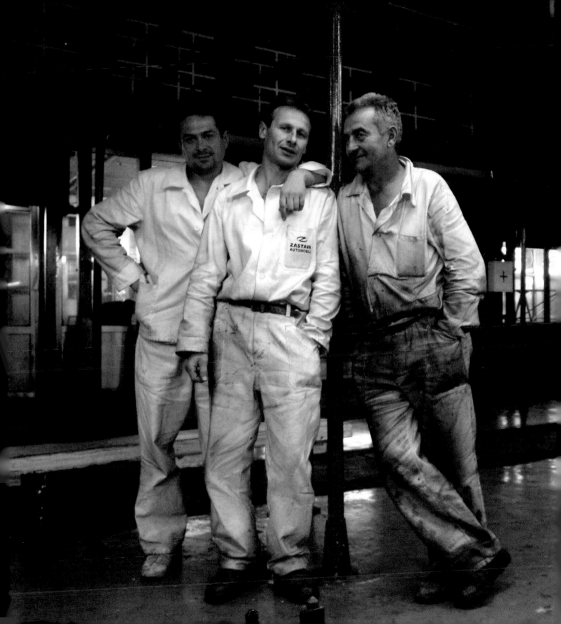

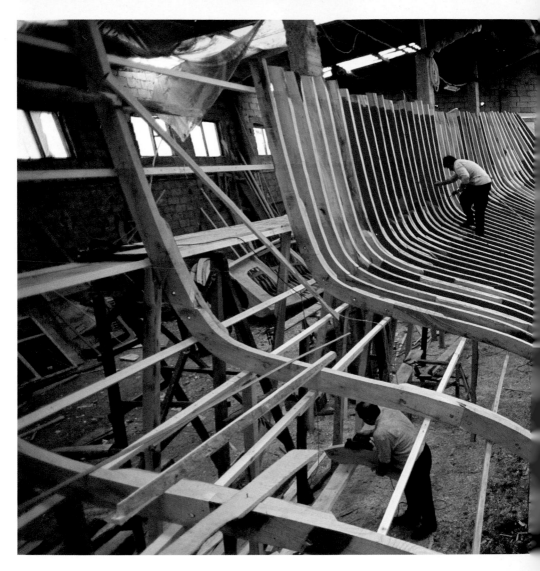

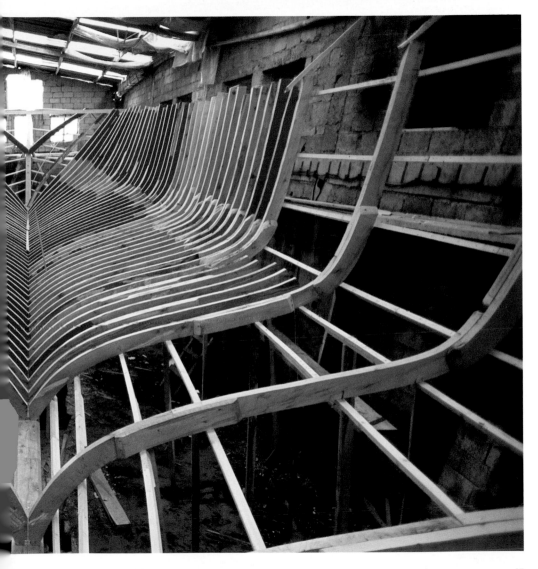

preceding pages:

RANDY OLSON
Handcarving the ribs of a Black Sea fishing vessel called a cektirme, Kapisuyu, Turkey
2000

WILLIAM ALBERT ALLARD
Street musician singing with her barrel organ, Paris
2002

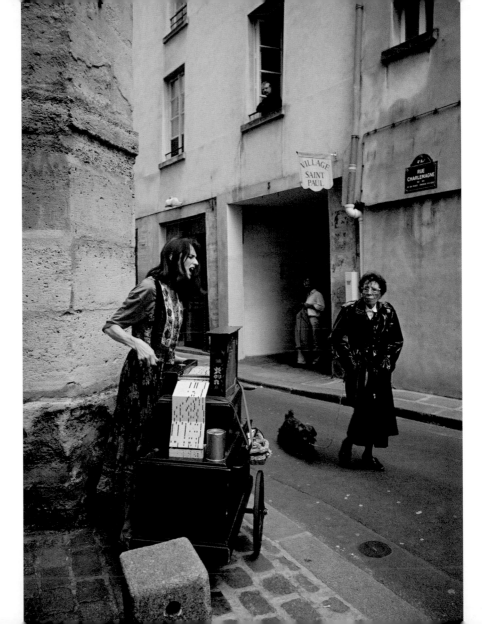

KENNETH GARRETT

Man panning a local stream for gold,
Germany
2003

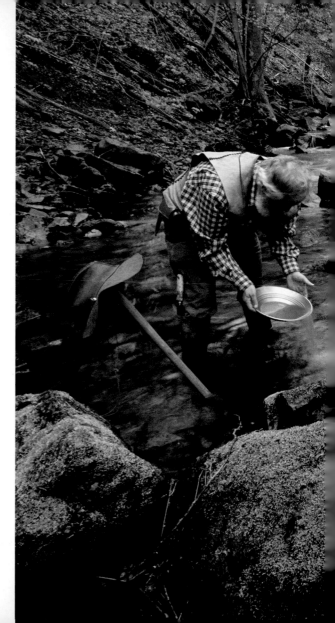

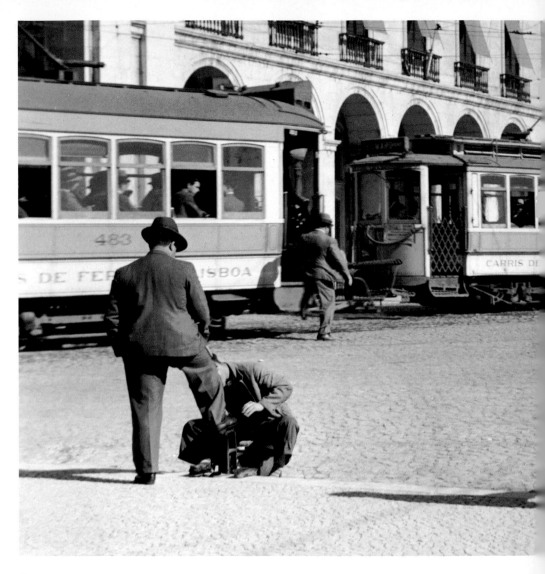

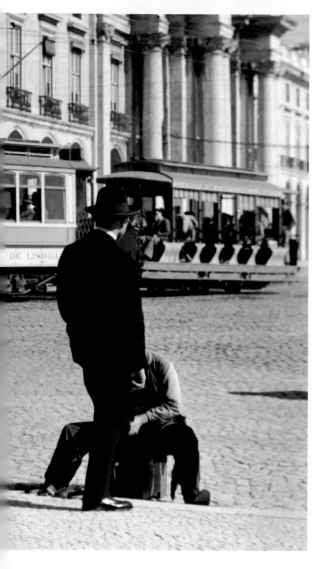

W. ROBERT MOORE

Bootblacks working in front of the
Ministry of Marine on the Praca do Comerio,
Lisbon, Portugal
1936

MAYNARD OWEN WILLIAMS

Women washing at a public fountain, Saint Paul du Var, France
circa 1920s

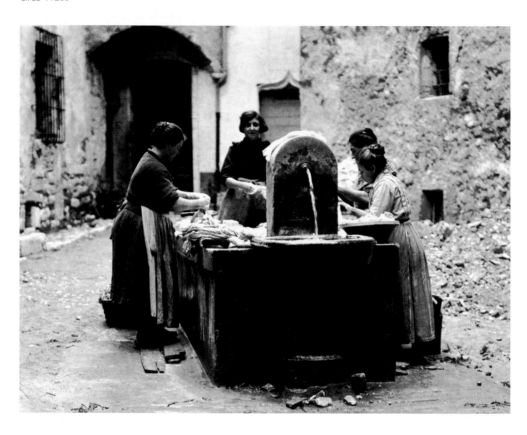

preceding pages:

GERD LUDWIG

Russian artist Andrey Bartenev performing with friends at his studio, Moscow
1996

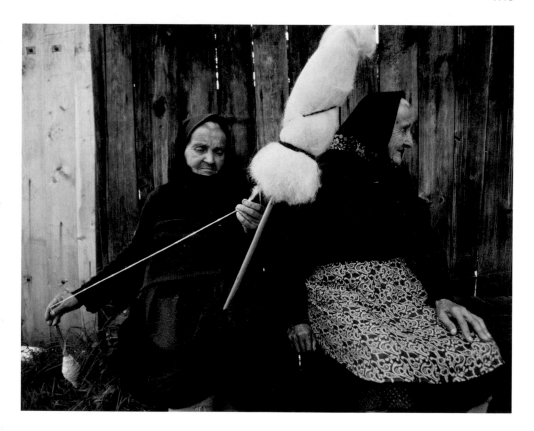

JULIE DENESHA
Roma settlement in Rakusy, Slovakia
2003

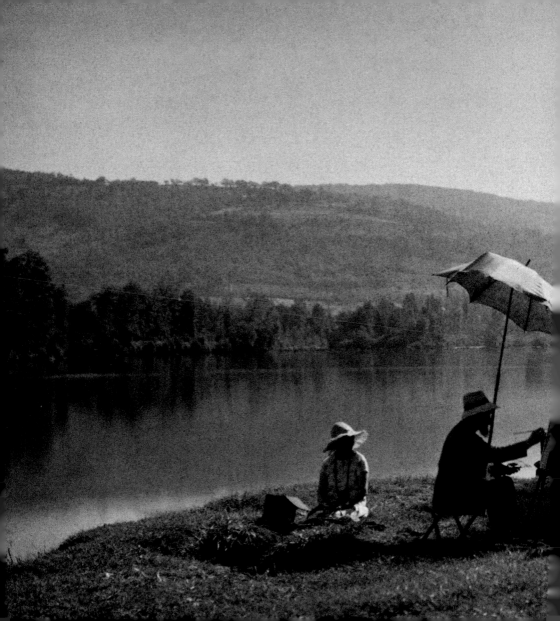

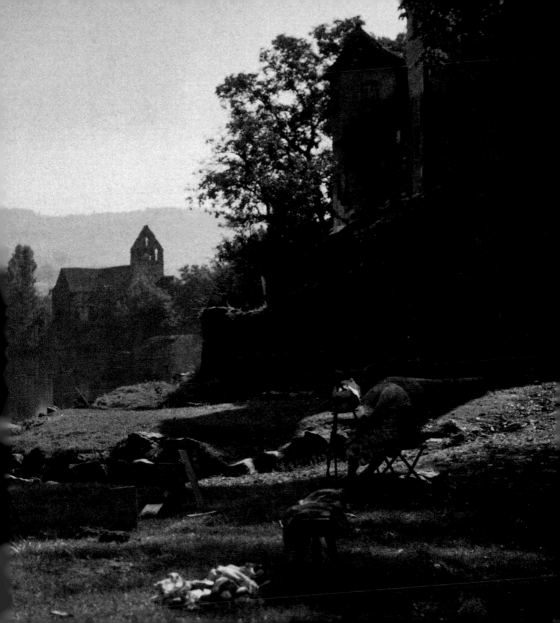

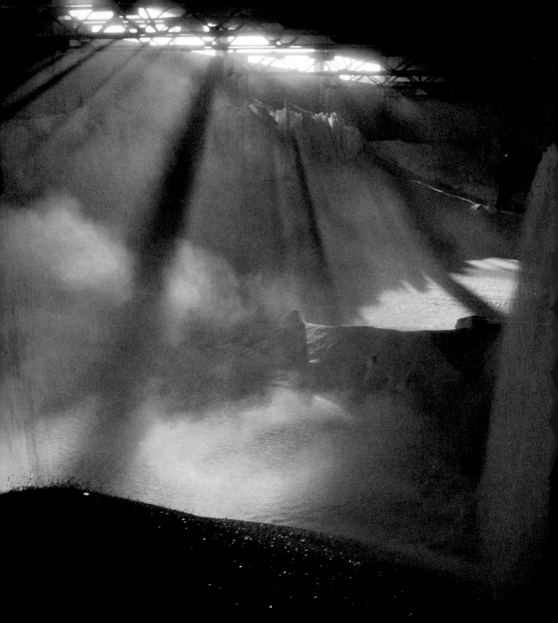

GERVAIS COURTELLEMONT

Autochrome of artists by the
Dordogne River, near
Beaulieu, France
circa 1920s

SISSE BRIMBERG

Sulfur being loaded into warehouse,
Megara Hyblaea, Sicily
1993

DAVID ALAN HARVEY

Dangerous work: matador and charging bull, Madrid, Spain
1977

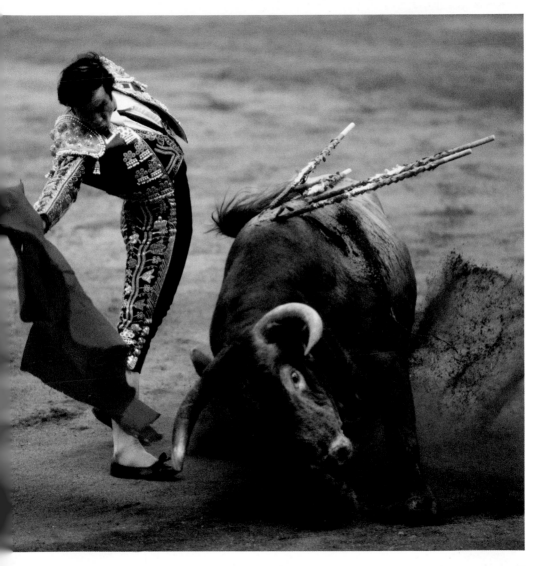

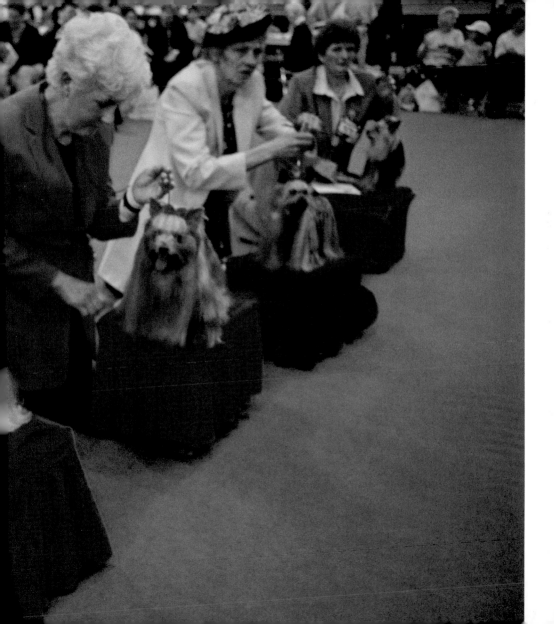

preceding pages:

RICHARD OLSENIUS
Yorkshire terriers being judged
at the Crufts Dog Show,
Birmingham, England
2001

GEORGE STEINMETZ
Giorgio Armani fine-tuning his spring
women's fashion show,
Milan
1991

preceding pages:

MARIA STENZEL
A children's hospital in Yar Sale, Russia
1996

BRUCE DALE
Cleaning glass and frame of Mona Lisa,
Louvre Museum, Paris
1966

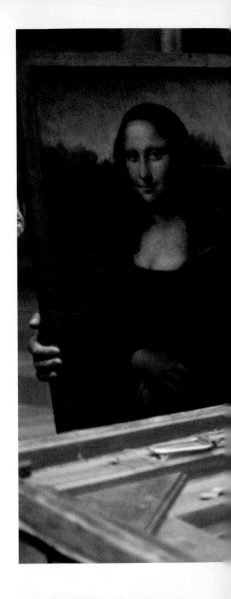

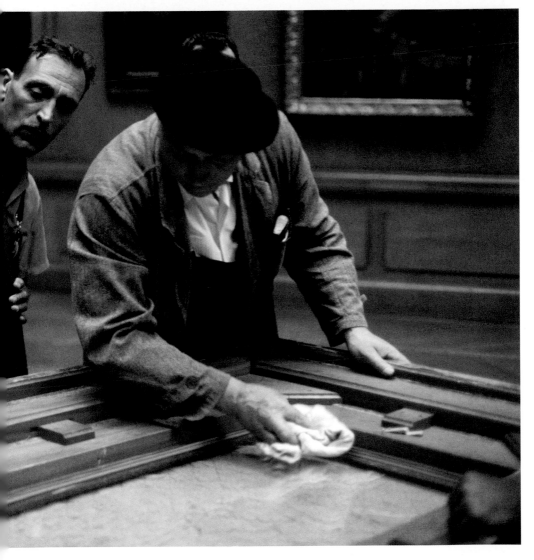

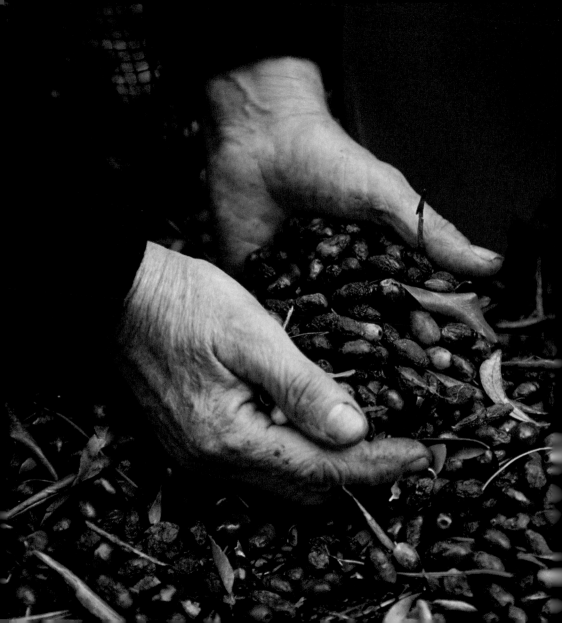

IRA BLOCK
Olives harvested for olive oil production,
Paxos, Greece
1997

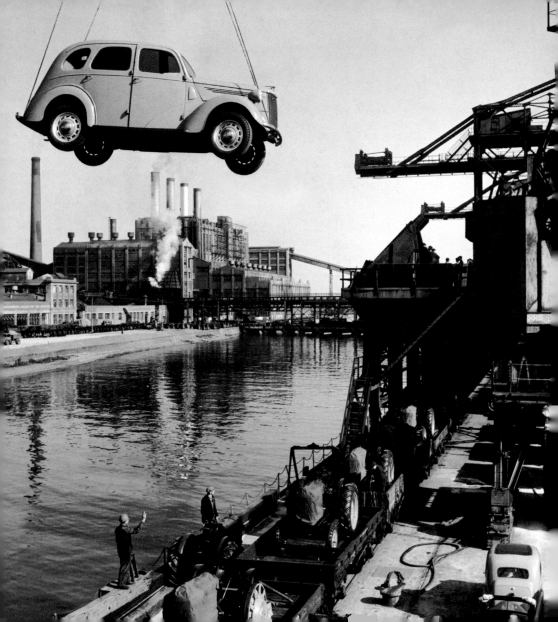

Agriculture

THE HUMAN BEINGS WHO DEVELOPED AGRICULTURE couldn't have imagined it would eventually spread around the planet and sustain a population of some 6.5 billion people. But once someone figured out that seeds could be harvested, stored, and planted again later, the course of human development was forever altered. Plant domestication, which archaeologists date to before 7000 B.C., produced more reliable and larger harvests. More food allowed population to rise and permanent villages to be established. Cultivation led to civilization.

The work of planting and harvesting continues. But for millions of us in advanced countries, food comes from the supermarket. We don't see fields being tilled or cattle being slaughtered, as in William Albert Allard's photo of a Peruvian abattoir. We just buy the beef and take the work on which all other work depends as a given. We assume this fertile planet and modern agriculture are indefinitely sustainable and can feed an ever-increasing population. If that's not true, the harvest may be unimaginably bitter.

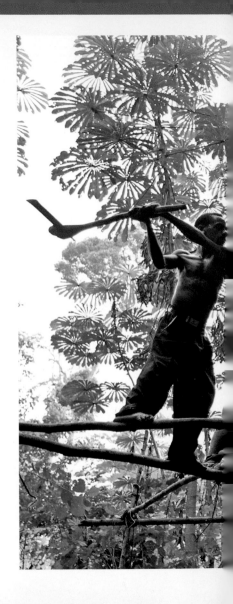

RANDY OLSON
Mbuti men clearing tropical hardwood to plant a garden, Democratic Republic of Congo
2004

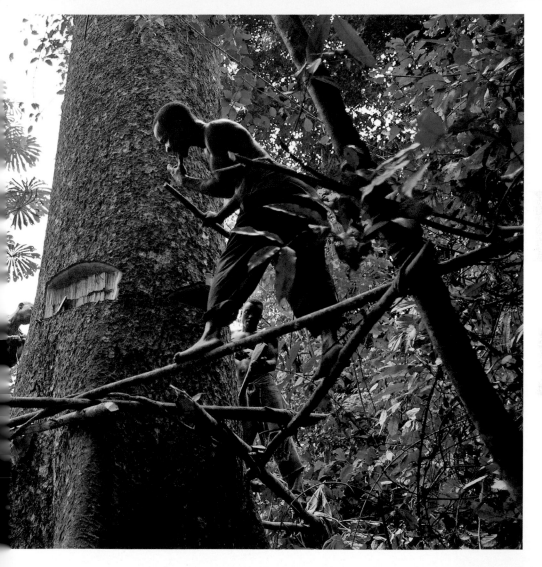

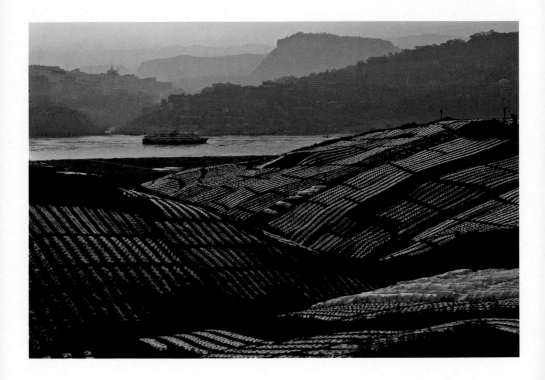

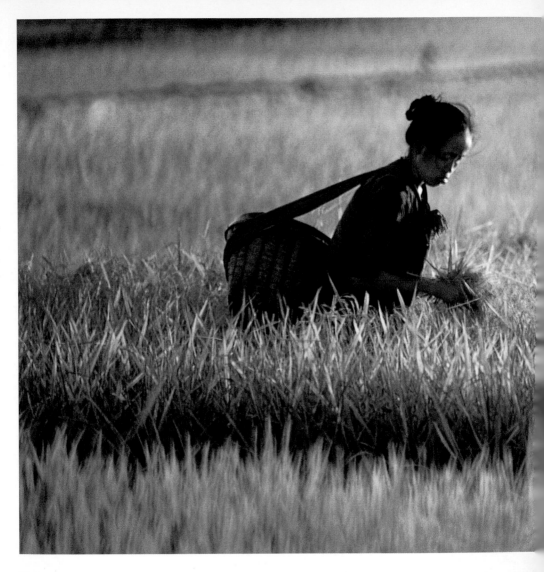

DAVID ALAN HARVEY
Washing a horse, Australia
2003

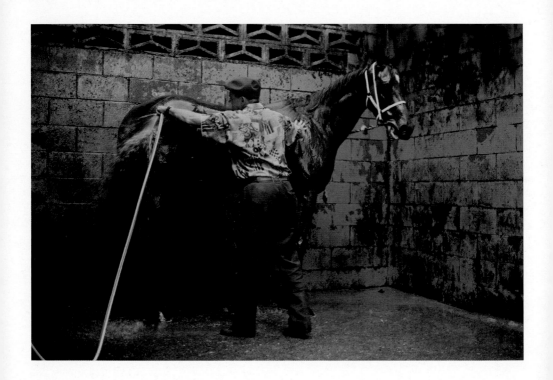

preceding pages:

DEAN CONGER
Rice farming in Prambanan, Java, Indonesia
1970

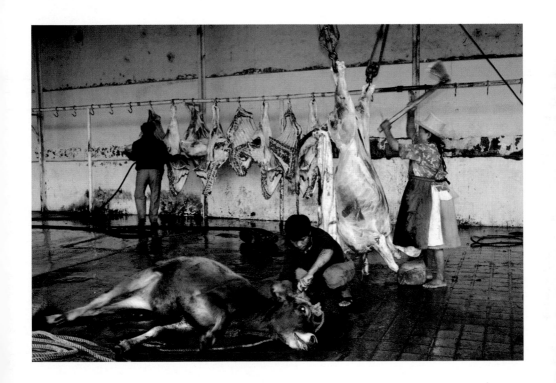

JACK DELANO

Cultivating sugarcane near Bethlehem,
St. Croix, Virgin Islands
1941

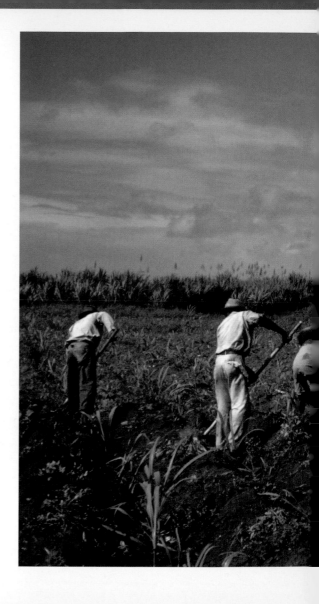

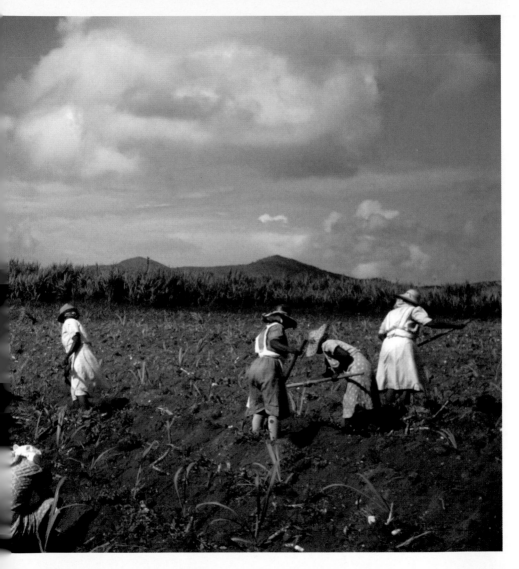

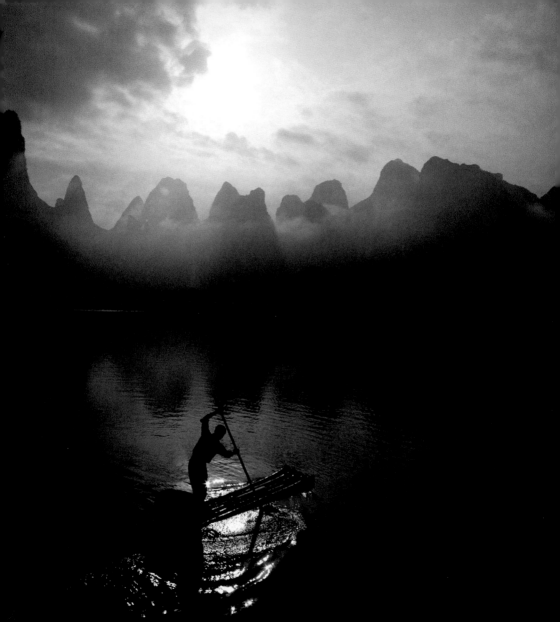

asia

A s the sun tries to burn through the haze, a fisherman poles his bamboo raft down China's Li River past the rugged karst formations known in Guangxi Province as the "Forest of Odd-Shaped Peaks." In James P. Blair's photograph, those limestone hulks, formed in prehistoric times when the area was a seabed, loom in the background, shrouded in gray mist. Their toothy shadows stretch toward the angler frozen in mid-stroke directly atop the sun's reflection in the water.

The scene is timeless, an evanescent moment of everyday drama. People have fished the Li River with nets, hooks, and lines or cormorants for thousands of years, either consuming what they catch or selling the fish at the towns and villages along the stream. Thanks to Blair's aesthetic, knowledge, and skill as a photographer, his picture, with its jagged peaks, veils of mist, and patches of softly modulated black, gray, and white, looks like a contemporary addition to the impressionistic, pen-and-ink lyricism of the grand tradition of Chinese landscape painting, which first flowered during the Song dynasty from 960 to 1279.

As in the best Chinese landscapes, the work and works of man, such as the fisherman and his raft, are a small but important part of the picture. They transport the viewer into the scene and provide a sense of scale on which the relationship between man and nature, at least in this instance, is built. Put simply, nature is awesome and unchanging, man puny and ephemeral. The majesty of this natural setting subsumes all individual human efforts.

So powerful is the landscape's physical beauty that the fisherman, the photographer, and anyone viewing the scene can lose themselves, if only for a moment, and the commonplace work depicted takes on a metaphysical cast. Fishing in this photo is solitary, contemplative, in harmony with nature, and in keeping with cultural traditions dating back thousands of years.

Were Confucius, the legendary Chinese philosopher whose influence extends throughout East Asia, to gaze upon the scene he might think things had changed little from his lifetime of 551 to 479 B.C.

But there are other visions of China and Asia that Confucius, who supposedly coined the phrase, "choose a job you love, and you will never have to work a day in your life," probably never entertained. Work in many parts of Asia today is a mass enterprise undertaken in urban, industrial settings where nature has been radically reshaped by mankind, and ancient cultural traditions matter less than investment, jobs, productivity, and profits.

One vision of work in that Asia can be seen in Gerd Ludwig's 1989 photo of a crowded, rain-slicked bridge in Guangzhou, the bustling capital of Guangdong Province in southern China. The natural world isn't awesome here. In fact, all we see of it is the weather. Man and his works dominate. A torrent of traffic pulls our eyes across the bridge and into the invisible city on the far side. One half of the frame is filled with buses, trucks, cars, motorcycles, and a yellow taxi shining like a beacon in the hazy, silvery light. The other half is packed with bicyclists wearing colorful plastic ponchos and a lesser stream of umbrella-bearing pedestrians.

The individual isn't being subsumed by nature's beauty and size in this bisected image—machine power on one side and raw muscle power, one of Asia's traditional strengths, on the other—but by modernity and the masses. Whether any of these folks love their jobs, we don't know. But they surely are working, transporting goods, passengers, or themselves through the rain, unaware that Ludwig was turning the moment into a dark, disquietingly lovely image of a Chinese boom-town.

That sense of physical exertion isn't present in Gueorgui Pinkhassov's photograph of Wang

Huizhong, a Chinese economist and statesman, looking serene in what has become the international uniform of high finance—dark suit, white shirt, and tie—while studying a newspaper in a gallery overlooking the stock exchange in Shanghai. Stock and bond prices flit across a giant screen in the background, just as they do in real time on innumerable screens in Tokyo, London, New York, and the world's other financial centers. Nothing in the scene suggests that China is a Communist country.

The flip side of China's economic boom is evident in the picture Ian Berry took in 1992 of a naked baby left to beg on the pavement near a pedestrian overpass in Shenzhen, another city in Guangdong province. Next to the child is a chipped enamel cup where people can drop money. That isn't happening at the moment the shutter clicked. The closest passerby, a stylishly dressed woman carrying a black bag, casts a wary glance at the baby and the photographer, without breaking stride. The other pedestrians don't even look.

These juxtapositions between traditional and modern forms of work, and between haves and have-nots, can be found in many countries around the world. They seem particularly pronounced in Asia, however. The divisions are exacerbated, perhaps, by the region's long history of civilization, its massive population and, above all, the remarkable economic transformation that has swept Asia's biggest countries over the past 30 years.

Since Chinese leader Deng Xiaoping pushed through market-oriented economic reforms of China's Communist economic system in 1978, the nation's output has quadrupled and its gross national product, the broadest measure of economic activity, has grown tenfold. Living standards for many of the country's 1.3 billion people have risen significantly. In recent years, India, home to the Indus Valley civiliza-tion, which dates back at least 5,000 years, has experienced an economic boom that has greatly expanded the middle class in its population of about one billion people. Taken together, China and India have raised more than 500 million of their citizens out of poverty since 1980.

Underlying those swift and dramatic macroeconomic changes is work. Hundreds of millions of people have switched from their traditional ways of making a living, such as farming and handicrafts, to go to work in modern industries and businesses such as software or financial services. Work is literally reconfiguring Asian life and landscape.

Those changes are not uniformly positive. Rapid industrialization has produced extremes of wealth and poverty and serious environmental problems including air and water pollution and soil erosion. Economic growth has not solved the region's pressing sociopolitical issues of overpopulation, poverty, and ethnic and religious conflicts. In much of Asia, the cheapest commodity still seems to be human muscle, just as it was when Henri Cartier-Bresson photographed men unloading barges by hand on the Chungking docks in 1958, a time when Chairman Mao Tse-tung's "Great Leap Forward" was supposedly modernizing China's economy.

The vast supply of labor in Asia exceeds the number of available jobs, putting downward pressure on wages. In China, for example, tens of millions of workers migrate between their native, rural areas and the crowded cities, seeking employment and surviving by taking low-wage, part-time jobs. Across Asia, tens of millions of people still live in poverty in rural areas, their lives untouched by the impressive rise in gross domestic product. Some people in the region's most remote areas still subsist by hunting and gathering with simple, homemade tools, much as their Stone Age forebears did.

As a group, the photographs in this chapter document the extremes of work found in Asia and the tension between ancient and modern ways that exists in many of the region's countries. While many of the pictures are beautiful they also raise broader questions about the positive and negative effects of rampant economic growth on societies in Asia and the rest of the world.

In some pictures, the work we see is unique to that place and culture. The work shown in Cary Wolinsky's photo of a man in Nara, Japan, collecting soot from the caps of rapeseed oil lamps in order to make sumi, or ink sticks, is as much a cultural ritual as it is a job. The soot the man is so carefully brushing into a tub will be mixed with cowhide glue and perfume, kneaded by foot, rolled into small, soft cylinders and pressed into decorative molds. In the hands of Japanese calligraphers, these sumi will become part of a centuries-old artistic tradition. No matter how high-tech Japan becomes, this work will continue to exist because the society values it.

The picture of two young men herding cattle in India, with one weary herdsman catching a nap on the railroad tracks, or the shot of the fishermen flinging their nets into the murky water of India's Birupa River, are examples of more mundane work, done as it has been for ages, that is still very much alive in the modern world.

Intellectual and spiritual work can also be rooted in tradition. Steve McCurry photographed a group of young monks studying Buddhist scripture in a Tibetan monastery. Sporting crimson robes and cloth headgear that looks like golden sunbonnets on steroids meant to focus their vision on the texts, the students sit cross-legged on a bare concrete floor. The image seems timeless until the eye lights on the sneakers and sweat socks peeking out from under some of their robes.

A more ominous look at youth working in Asia is provided by Reza's photograph of young boys building handguns in a weapons workshop in Sialkot, Pakistan. The pistols they produce will be sold on the black market. The four boys, sitting in a row at their work stations like students in some school dedicated to destruction, may be making guns only because they need the money to survive. But there is something utterly chilling in the way they gaze at their work, brows furrowed in the kind of concentration children in other countries devote to video games.

The young gunsmiths highlight one of work's most amazing qualities; it is often invisible except to the people doing it. That China, for example, manufactures and exports all manner of goods is no secret. Consumers all over the world see the words "made in China" on the televisions, sweaters, sneakers, and light bulbs they purchase. We know someone, somewhere made these things; other people packed and shipped them. Yet, most of us have never been to China or even seen images of its factories, their employees, or the supply chain that moves the goods to us.

Edward Burtynsky has. In 2005 he traveled through China making extraordinary photographs of its booming economy. In his "Manufacturing #17, Deda Chicken Processing Plant, Dehui City, Jilin Province, China, 2005," a vast phalanx of workers clad in pink sanitary suits, blue aprons, white rubber knee boots, and white surgical masks form a pastel path pulling viewers into the picture's depths. Most of the workers' heads are bowed as if this were a mass prayer meeting at that altar of capitalism, the assembly line.

In this instance, it is actually disassembly moving down the lines. Most of the hundreds of employees in the gigantic plant are wielding knives and cutting up chickens. Beneath the cheerful garb, they are men and women being paid to process poultry and produce a profit. Somewhere in that great reeducation

camp in the sky, Chairman Mao and the heavenly hosts of Chinese poultry must be weeping.

People chopping chickens in China might seem an unlikely subject for fine art. In Burtynsky's photo, however, that work, the people doing it, and the factory in which they labor are no longer invisible, they are mesmerizingly beautiful. As a photograph, their work seems, at first, to have been sanitized for our enjoyment. The poultry plant becomes silent and motionless, its odors eliminated, its light and temperature constant, its purpose utterly changed. Color, texture, and form take precedence over gizzards, wings, and split breasts.

Burtynsky didn't dress the workers or pose them. He saw the beauty that was there and photographed it, an act Confucius, who once said "everything has beauty, but not everyone sees it," might have applauded. In all likelihood, Burtynsky made many prints of the Deda Plant. He selected the one we see here because it best expressed what he saw and felt in the factory. He saw beauty, but it is an ambiguous beauty. Something unsettling emanates from it.

The photograph, as French film director Jean-Luc Godard once said, "is not a reflection of reality, but instead the reality of reflection." Even as art, the poultry plant can't escape its place in the food chain, which is also a long chain of work. Beyond the inevitable question of which comes first, the chicken or the egg, that process begins with one of mankind's most ancient forms of work, animal husbandry, and continues on with transportation, slaughter, processing, storage, wholesaling, retailing, cooking, serving, eating, cleaning up and waste disposal.

Nor can the factory escape being a business. Within the beauty of that photograph is a whole world of work, full of people doing all kinds of jobs, some of which aren't pleasant to contemplate when we're about to dig into a steaming mound of Kung Pao chicken. An environmentalist might look at the pink ranks and think of the vast quantities of waste the chickens produce and how it can contaminate China's streams, like the Li River, which are already suffering from growth-related pollution. A vegetarian might argue that the grain fed to the fowl would be more efficiently used if consumed by humans.

Burtynsky's picture doesn't resolve such conflicts. It embraces the beauty and the beastliness and leaves us to decide which we feel is more important. "These images are meant as metaphors to the dilemma of our modern existence; they search for a dialogue between attraction and repulsion, seduction and fear," he wrote in an artist's statement. "We are drawn by desire—a chance at good living, yet we are consciously or unconsciously aware that the world is suffering for our success. Our dependence on nature to provide the materials for our consumption and our concern for the health of our planet sets us into an uneasy contradiction. For me, these images function as reflecting pools of our times."

As the times change, so do attitudes toward work. Karl Marx once wrote, "Workers of the world unite; you have nothing to lose but your chains." Although China is a Communist country, that notion doesn't appear to have much currency among its toiling masses. Lose your chains and you lose your paycheck. No paycheck, no money. No money, no chicken in your wok. Next thing you know, you're back on the Li River, poling through the sun's reflection, hoping to catch some dinner or a break back at the start of the food chain.

Karl had a thought on that, too, one worthy of another Marx named Groucho. "Catch a man a fish and you can sell it to him. Teach a man to fish and you ruin a beautiful business opportunity." That is, of course, if it works. In our world, that's always an open question.

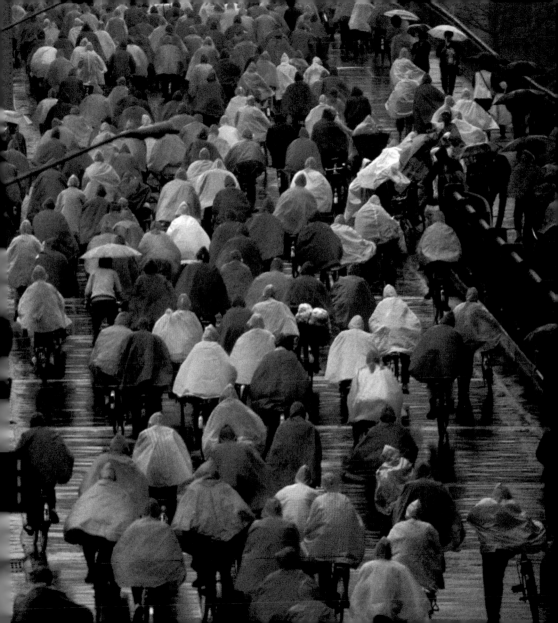

JUSTIN GUARIGLIA
Buddhist monks pulling land mine from ground, Cambodia
2001

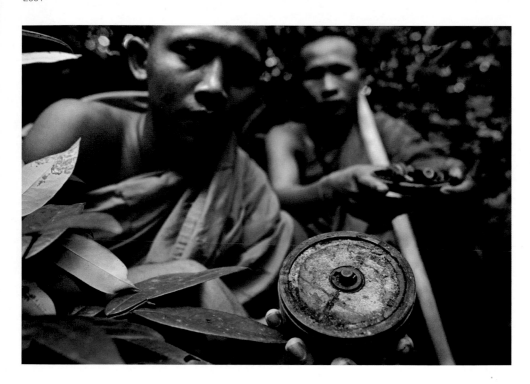

preceding pages:

GERD LUDWIG
Commuters on bridge, Guangzhou, China
1989

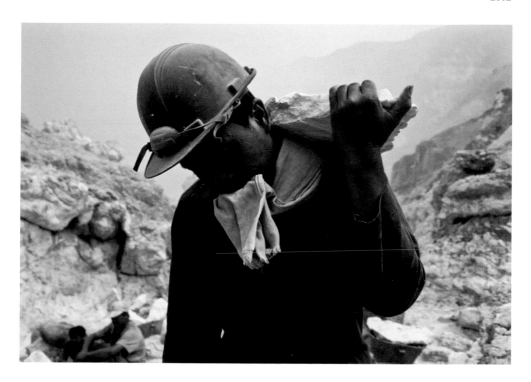

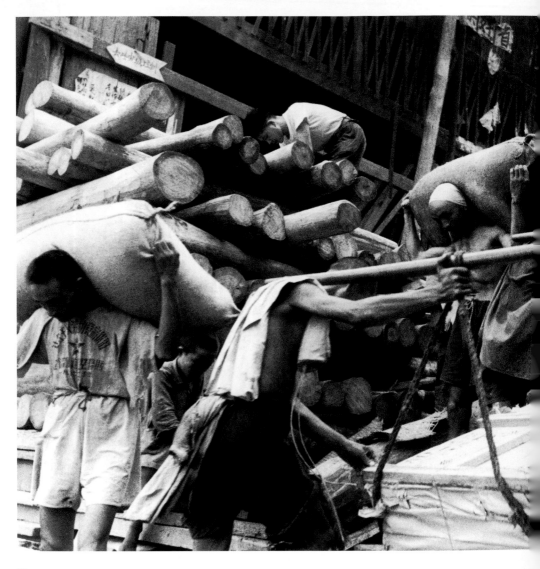

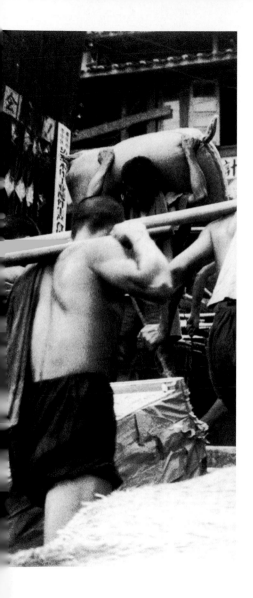

STEVE McCURRY

The governor of Bombay and his wife being served tea at his palace, India
1993

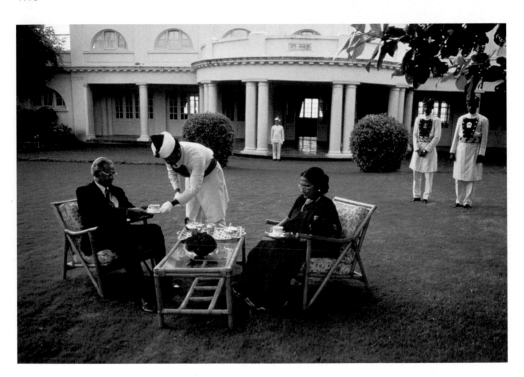

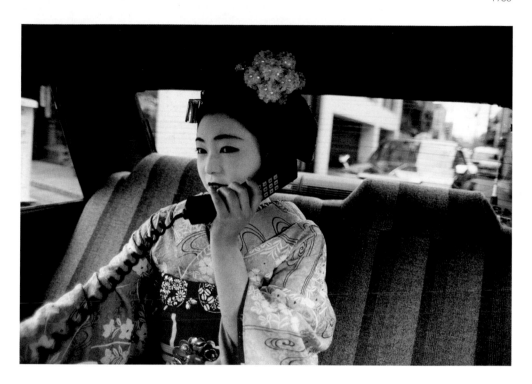

STEVE McCURRY
Young monks studying Buddhist
scripture at monastery in
Lithang, Tibet
1999

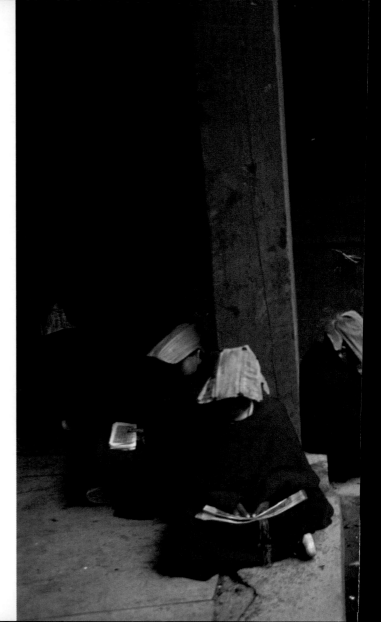

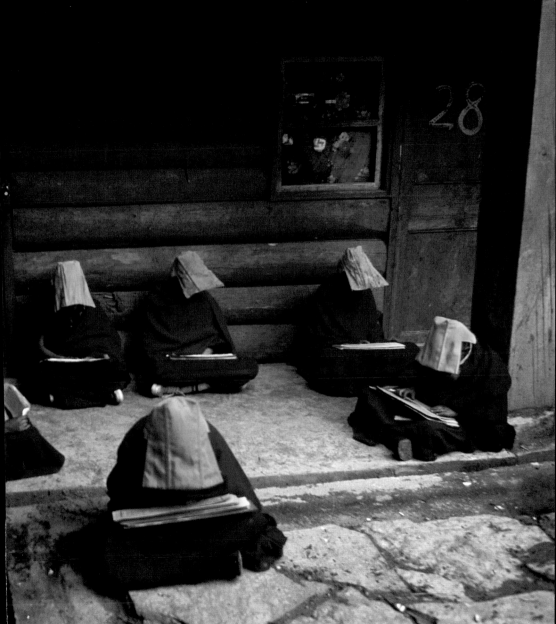

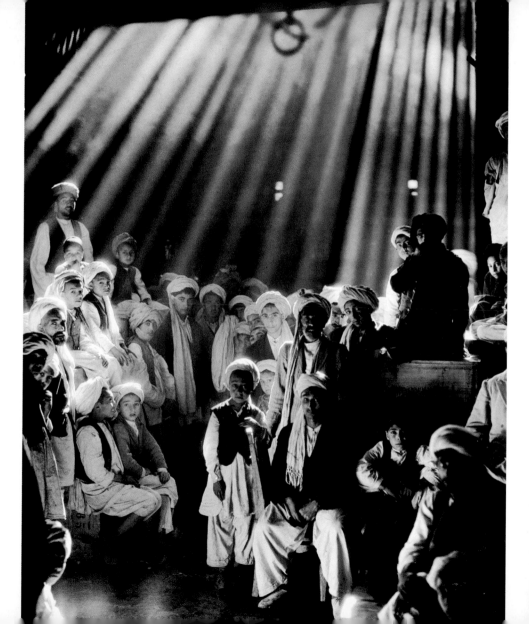

MAYNARD OWEN WILLIAMS
Sunlight shining on men and boys in warehouse, Herat, Afghanistan
1931

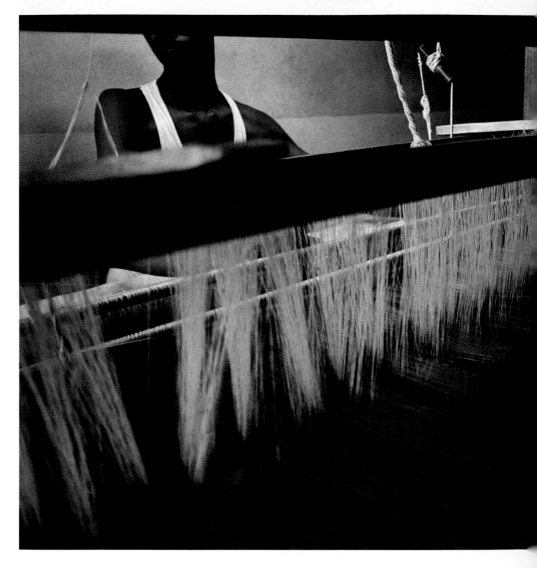

JODI COBB
Young worker operating loom in silk factory,
Kanchipuram, India
2002

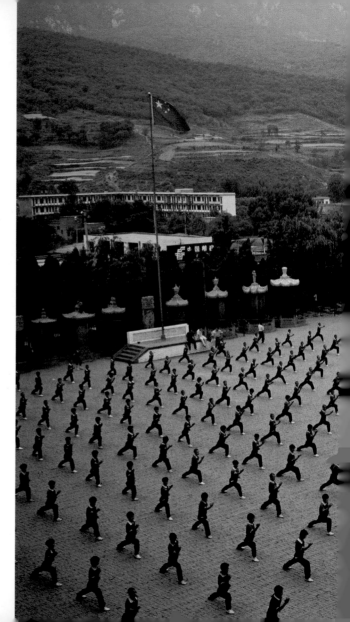

JUSTIN GUARIGLIA
Children practicing kung fu
at Ta Gou Academy,
Song Shan, Henan, China
2003

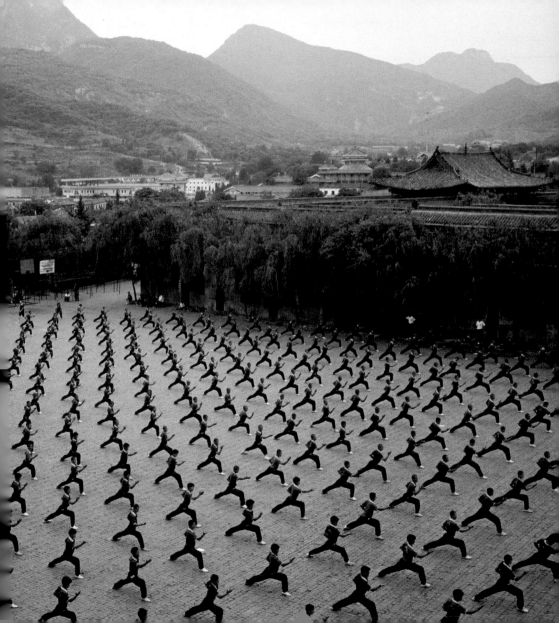

STEVE McCURRY
Child dressed as Hindu diety Lord Shiva, begging, Hardiwar, India
1998

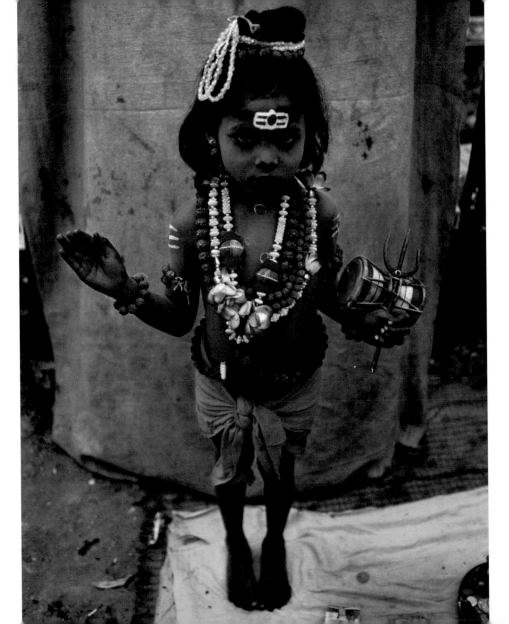

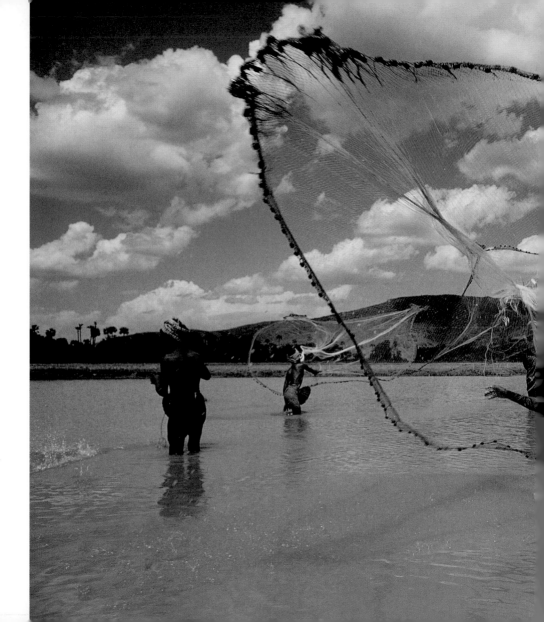

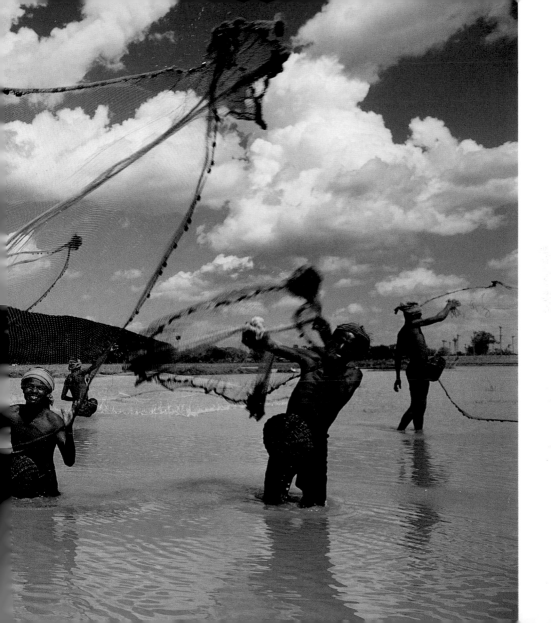

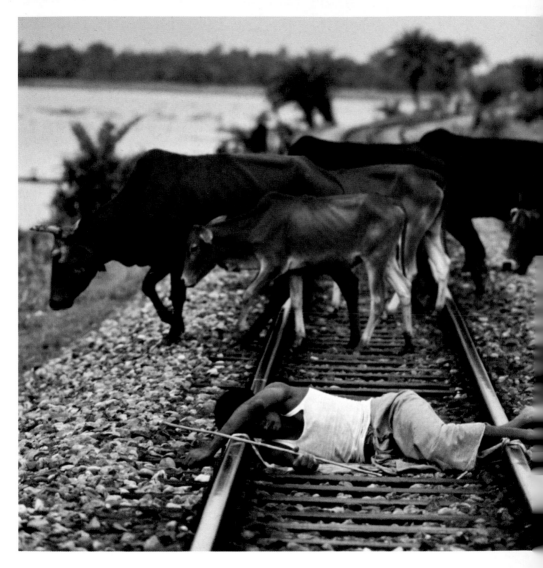

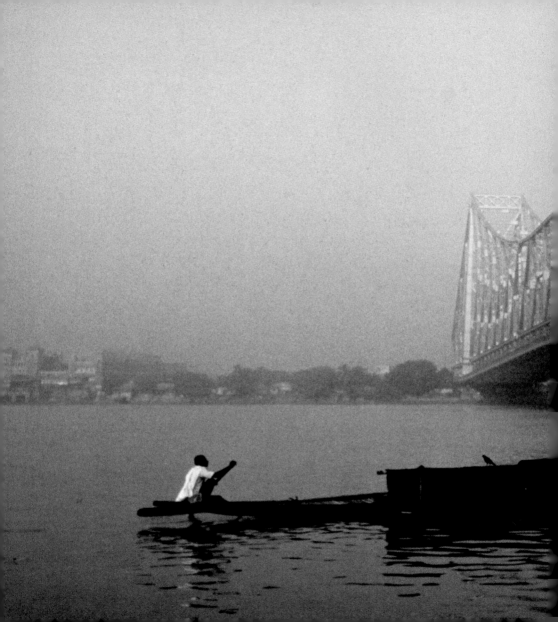

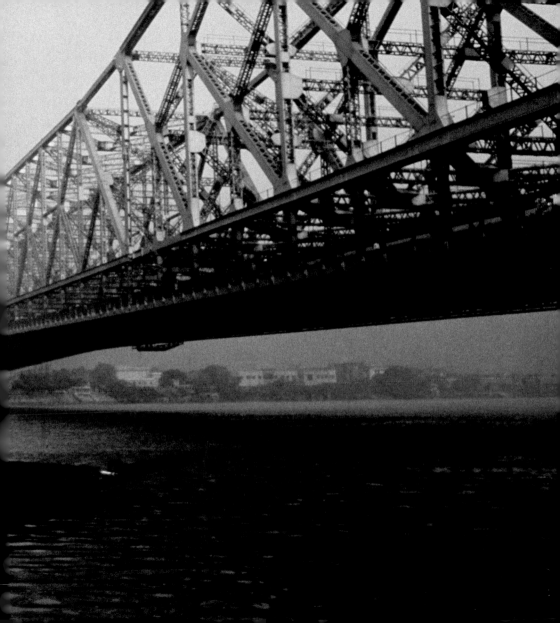

preceding pages:

ED GEORGE

Man guiding boat under bridge on the
Hooghly River, Calcutta, India
circa 1996

GUEORGUI PINKHASSOV

Wang Huizhong, economist and
statesman at the Shanghai
stock exchange
1995

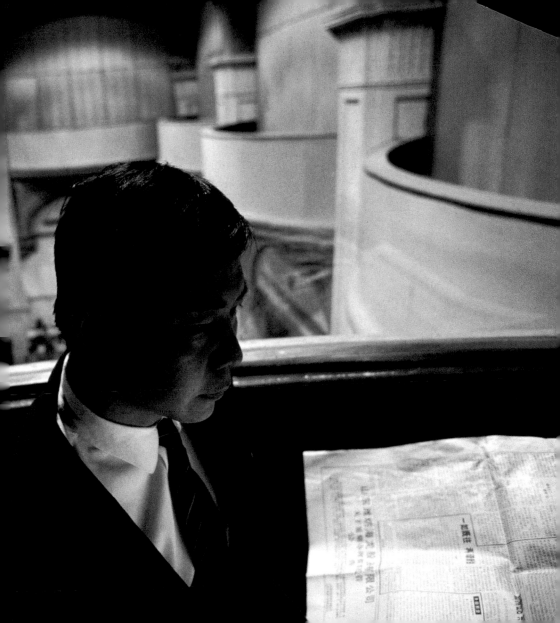

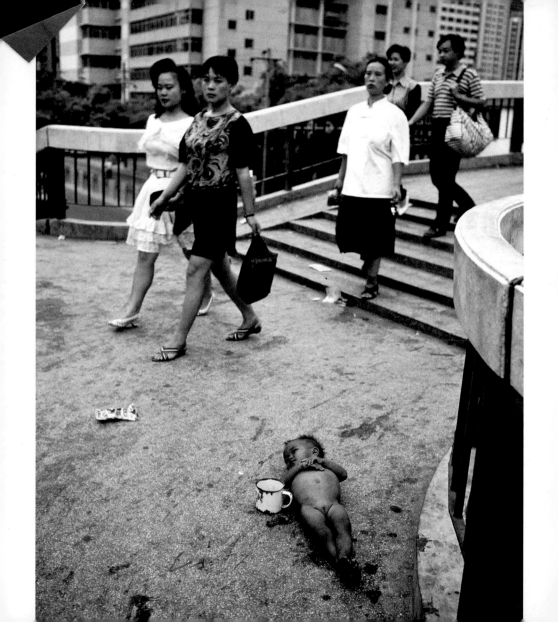

IAN BERRY
Baby left to beg alone, Guangdong, Shenzhen, China
1992

REZA
Boys building handguns, Sialkot, Pakistan
2004

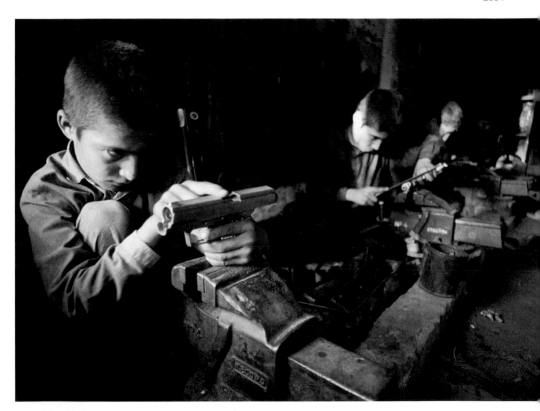

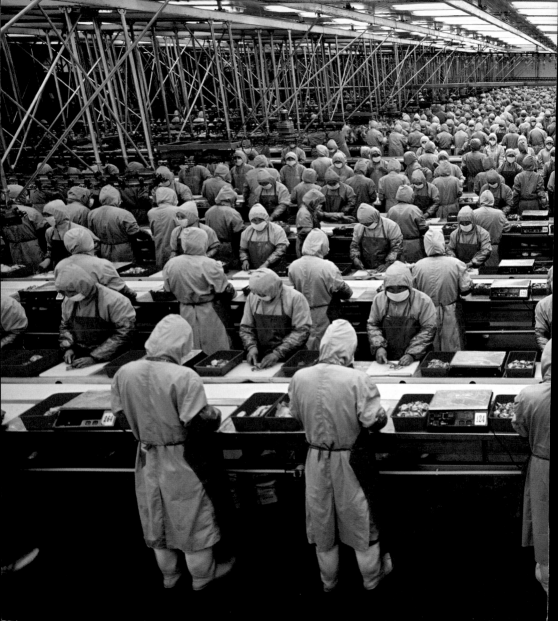

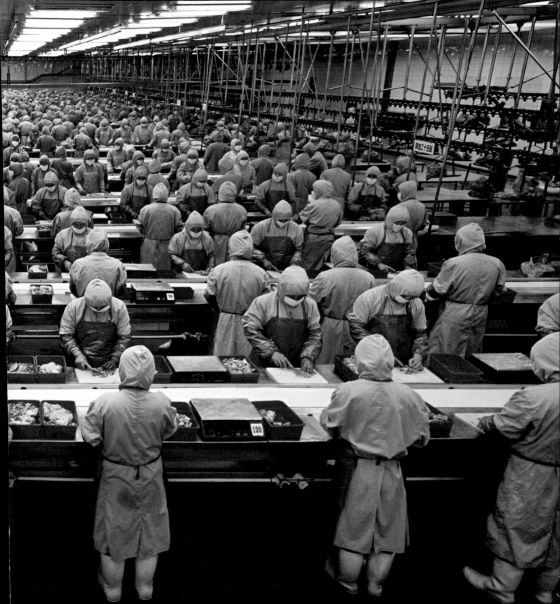

preceding pages:

EDWARD BURTYNSKY

"Manufacturing #17,"
Deda Chicken Processing Plant,
Dehui City, Jilin Province, China
2005

CHARLES O'REAR

Stock traders relaxing to
musics in head domes,
Tokyo, Japan
1992

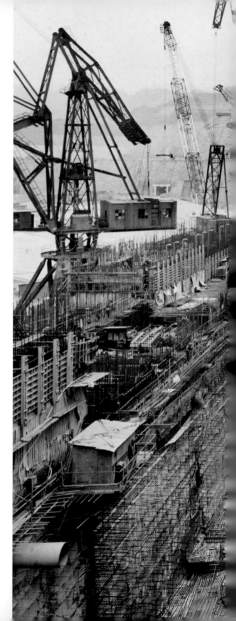

EDWARD BURTYNSKY
"Dam #6," Three Gorges Dam Project,
Yangtze River, China
2005

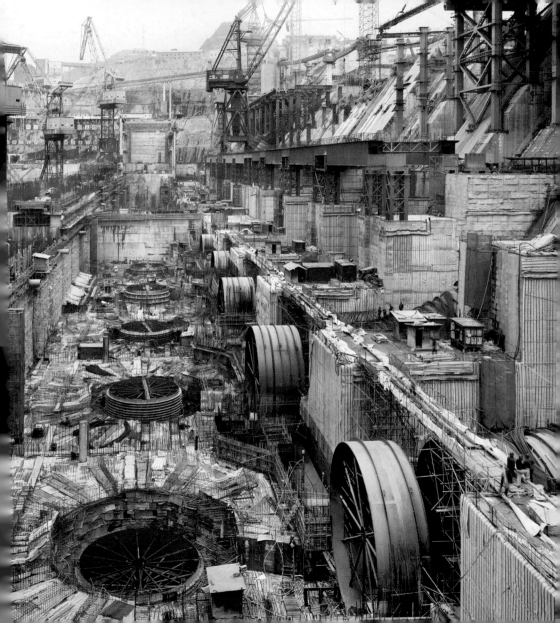

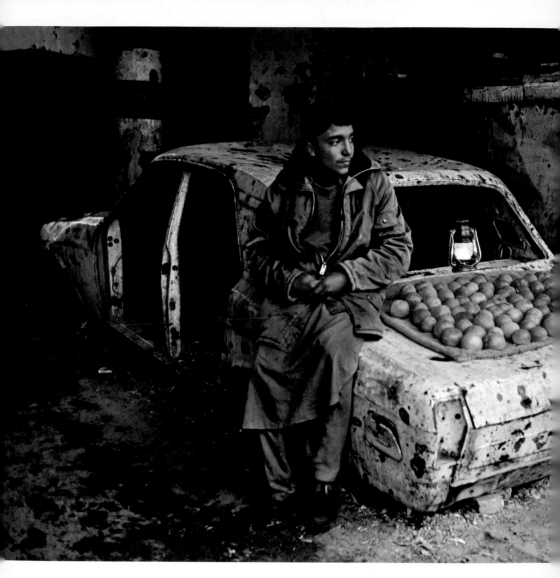

STEVE McCURRY
Boy selling oranges at former police station
on burned-out police car, Afganistan
2002

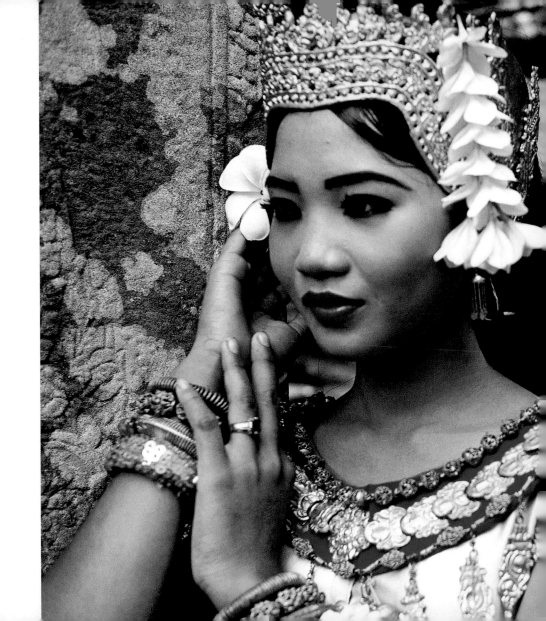

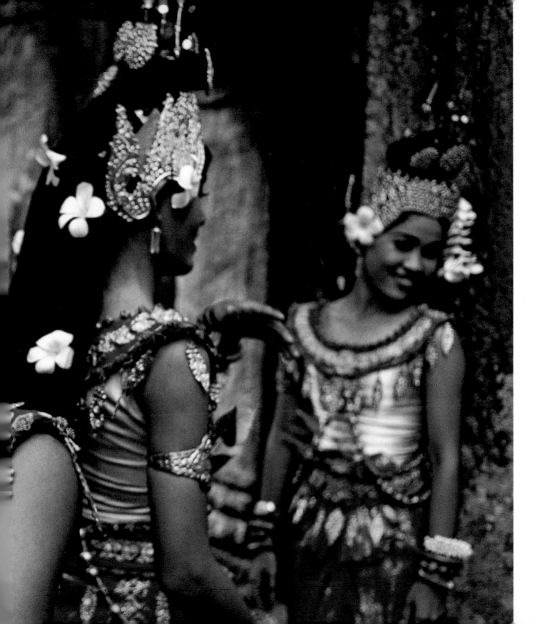

STEVE McCURRY
Dancer applying makeup before performance at Preah Khan Temple, Angkor, Cambodia
2000

JODI COBB
A woman having her hair styled at a beauty salon in Shanghai, China
1981

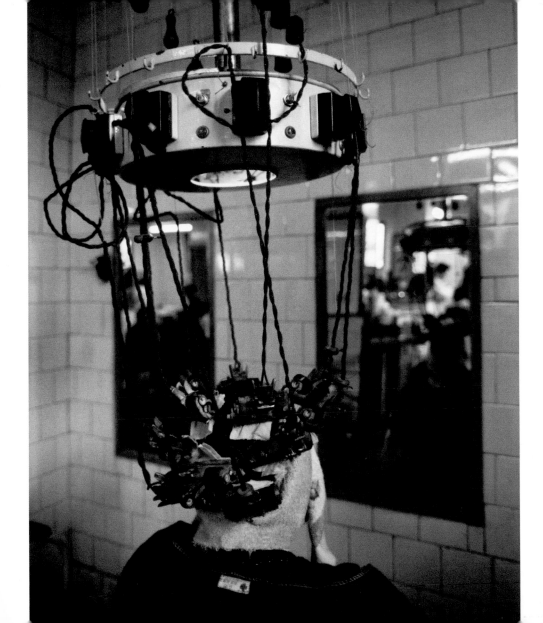

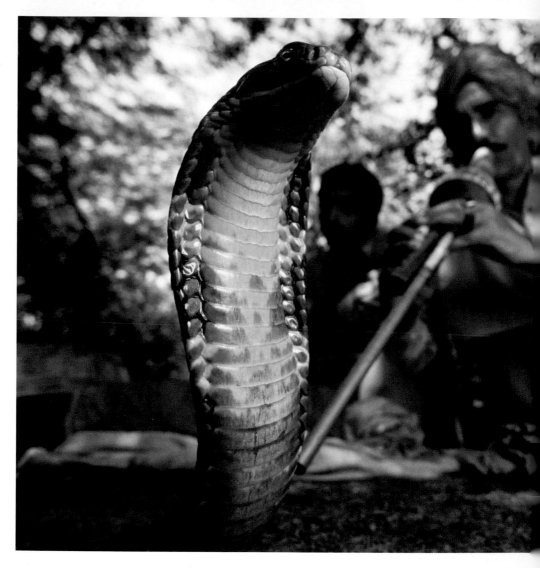

MATTIAS KLUM
Snake charmer playing flute for king cobra,
New Delhi, India
2000

following pages:

JUSTIN GUARIGLIA
Boy in front of rickshaw whose driver is resting,
Beijing, China
1999

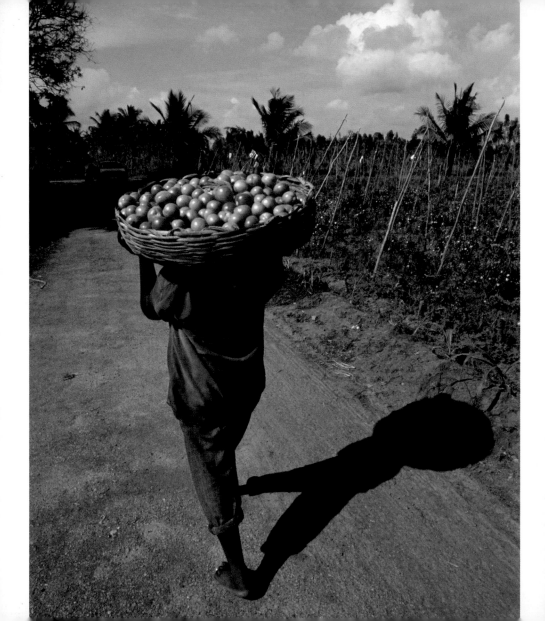

africa

JIM RICHARDSON
Man carrying basketful of tomatoes, Kenya
2001

Somewhere in Kenya, Jim Richardson photographed a man who was walking down a country road with a basketful of tomatoes on his head. The bright sunlight etches the worker's shadow in the dirt, creating an elongated figure topped by a giant orb that calls to mind some rural Atlas bearing the weight of a complex, conflicted, and wondrous place called Africa.

That metaphorical work and weight turns real and heavy in many of the photographs in this chapter, including Randy Olson's image of a Dinka woman cooking in South Sudan. Dressed in a colorful, patterned skirt, she sits next to a pot of leaves stewing on a stone hearth. Her face and shoulders are out of the frame. The focal point of the image is the earthenware pot filled with greenery that will be her next meal.

Two images of Africa, neither the kind of stereotypical image often found in magazines or calendars or coffee-table books. There is no wildlife, no grand vistas, no touristic or scientific implications. The subjects aren't wandering the Serengeti, battling a Saharan sandstorm, or posing in a picturesque village. In fact, we don't see their faces, learn their names, or know their exact locations. They are just a man and a woman, in different parts of a vast continent, engaged in the mundane work of transporting fruit and preparing a meal, something people do the world over.

Both pictures are beautiful, albeit in different ways. Richardson's scene features the classic landscape color scheme and perspective: a slightly elevated viewpoint; brown in the foreground leading to green in the middle ground and a blue sky in the upper quarter of the picture plane creating a clearly demarcated horizon. The foreground figure leads the eye into the flat expanse. The impression conveyed is of fertile land, abundant fruit, and manual labor under the African sun.

Randy Olson's photo is less conventional, aesthetically akin to abstract painting, but also intensely human. Because of the oblique angle he chose, there is no horizon, and the ground, an Anselm Kiefer-like mélange of brown, black, gray, and white tones textured with sticks and debris, seems to slope upwards, making it seem as if the woman, the fire, and her dinner are about to slide into the viewers' world. The contrast between the dirt and the green leaves and between the woman's dark brown skin and her clothing is striking.

Both photos are true and both are, in a sense, deceptive. The photographers saw what they saw and made a picture. It is, however, a momentary truth created by light rushing through a lens into a box, an eye-blink in eternity when time, place, people, and action coalesced into a picture. Then life moved on.

And there's the rub. Life and work in Africa move differently than they do in the Western industrial world. Africa is the world's second-largest and second most populous continent, after Asia. It is home to the oldest inhabited territory on Earth and widely believed to be the place where the human race originated. In socioeconomic terms, Africa is the world's most culturally diverse continent and also the poorest.

On a purely visual level, those facts aren't self-evident in these photographs. The work depicted is familiar, the Africans doing it appear to be in fairly good shape as they farm, fish, mine, sell, trade, guard, transport, build, operate machinery, dye, tan, and iron.

The difference is that these things are being done by people of color living in Africa, where an array of political, economic, and social woes currently afflict many nations and peoples. The roots of those conflicts are inextricably tangled with the issues of race, racism, and economic exploitation that dominate Africa's modern history and continue to affect its contemporary life.

The spectrum of work in Africa is much as it is elsewhere, ranging from beggars and prostitutes to

prelates and presidents. There are, of course, many Africans of European, Asian, and Middle Eastern descent. But for the majority of the millions living there, most of them dark-skinned and native to the continent, work is a matter of subsistence and survival. Many of these photographs touch on this sense of existential struggle, of people barely managing to keep themselves and their families alive.

If that only meant following age-old traditions of hunting, gathering, raising crops, and tending herds, work and life could be described as strenuous but not unpleasant. But for millions of Africans, traditional ways of life, which survived centuries of religious, ethnic, tribal, and clan rivalries, as well as the destruction of existing social structures by white colonial conquest and the subsequent struggles of independence, are being disrupted by war, genocide, famine, and economic exploitation.

Even in the best of times, agrarian, Nilotic cultures such as the Dinka along the White Nile or the Anuak in southwest Ethiopia and South Sudan depend on natural forces. If the rains don't come or the locusts do, crops fail and hunger sets in. Unfortunately, the times are currently so tumultuous for those peoples that the weather and pests are irrelevant.

Sudan has been wracked by a lengthy civil war that only ended in 2005, after killing and displacing millions, including many Dinkas. In Ethiopia, government troops have driven Anuaks from their homelands because they resisted military conscription. Many fled to Sudan. As a result, subsistence has shifted from farming and hunting game or fishing to flight, exile, armed struggle, and living in refugee camps, relying on outsiders for food, shelter, and medical care. Relief work is widespread in Africa today.

The photographs of the Dinka woman cooking leaves or the Anuak man keeping watch over a field of sorghum—moments turned into truthful, beautiful pictures—can't tell us where those people can be found today or whether they are still alive. The pictures don't lie and the photographers aren't liars, to paraphrase Lewis Hine, but photographs are by nature static. The situation in much of Africa today is anything but.

Like many of the relief workers, the photographers who took the pictures in this chapter were also outsiders, most of them white Americans or Europeans. That matters because their eye is affected by the Western aesthetic, as witness the landscape conventions in Richardson's shot of the man carrying tomatoes. They are trained to seek beauty and, consciously or subconsciously, they do it even in places where awful things are happening to innocent people. Beautiful or not, no photograph or body of photographs can encompass the reality of mass suffering.

The photographers whose work you see here were aware of their status as outsiders, the limits of their medium, and their audience. When they took these pictures, in South Africa, the Republic of Congo, Nigeria, Chad, Libya, and elsewhere, they didn't pretend to be indigenous or try to avoid beauty. Instead, they employed its elements—form, line, color, light, shadow, and composition—as a veneer that draws us, their audience, to consider at least a few of Africa's social and economic issues.

Some of their pictures show work in places where the cultural and economic norms of advanced industrial societies, such as mass employment, public education, and strong, individual work ethics, weren't present before colonialism and still don't exist. Many of Africa's tribal cultures are communal. Work, such as agriculture, is often a collective undertaking, divided according to gender and age. It is not a central element in personal or cultural identity. The 40-hour work week is unknown.

The Kikuyu women photographed by H. T. Cowling as they spread coffee beans to dry in Kenya in 1923 never punched a time-clock or attended a power lunch. Pausing to look into the camera was a brief respite in their lives. Kikuyu society was and is patriarchal. Women typically work from early morning when they rise to prepare breakfast and heat bathing water until late at night. In between, they cook all meals, work in the fields, tend the cattle, haul water and clean up. That translates roughly into an 18-hour work day, every day.

Whether most Kikuyu women are satisfied with their work-filled lives, I don't know. Should they wish to change their way of life, Kenya at least offers some opportunities. By African standards, it has a relatively stable government and economy. In many other parts of Africa, however, there is little if any opportunity for a person wanting to change their work or their lives. Like millions of people around the world, work in such places is dictated by circumstance.

Circumstance isn't always a disadvantage. Some African children are born into relatively privileged families that have wealth, power, and status in their societies. Others are less fortunate. The Herero woman Chris Johns photographed wearing an elegant Victorian dress and hat clearly enjoys a loftier economic status than her Bushman servant who is ironing clothes.

Other Africans don't have the option to trade the hunter-gather lifestyle for a job in domestic service or industry because those things don't exist where they live. Platitudes about work being all-conquering, or it not being work at all if you choose to do something you love, assume that people have a choice in their work and can pursue it in peace. Sometimes, however, that isn't the case.

A boy or girl may be born with a genius for mathematics, music, farming, or carpentry. If they are born into poverty or into a culture that limits access to certain kinds of work based on religion, ethnicity, or gender, their chances of realizing or utilizing those gifts are diminished. Other limiting factors include bad or no schools, lack of public infrastructure, inadequate health care, poor sanitation, and war. Those things, which Africa has in abundance, also proscribe adults' work options.

South Sudan, for example, got its own government following a peace agreement with Sudan reached in 2005 after two decades of civil war that left two million people dead and four million displaced. But many of the 48 members of its new parliament have never worked in government. Some are illiterate. Government employees' offices have no phones or electricity. While donors have promised some $4.5 billion in development aid, the government must develop the means and expertise to use it.

The situation is not nearly so bleak in more prosperous nations such as South Africa and Nigeria. Ed Kashi's photo of a longshoreman napping in the cab of his crane with the skyline of Durban, South Africa, in the background is a scene that could be found on the docks of an American or European seaport.

Many cities, such as Lagos, are crowded and bustling with economic activity. Nigerians have flocked to Lagos from the countryside seeking opportunities to better their lives. With some 13 million residents, it is one of the fastest growing cities in the world.

Several thousand poor residents lived in Makoko, a sprawling slum built on marshy ground that flooded so often canoes were the most reliable means of transportation. There was no public sanitation. Multiple families shared pit latrines. By most accounts, it was a dangerous place, "was" being the key word.

Makoko, seen in Stuart Franklin's photograph, no longer exists. The government had the slum razed in April 2005, forcibly evicting its residents. Bulldozers

leveled homes, churches, and even medical clinics to carry out a court order granting ownership of the area to a private landowner. With the city growing so fast, the competition among property developers for land is intense. Franklin didn't intend to deceive anyone with his photograph. Events altered its context, turning it into documentation of the past rather than the present.

Economic exploitation is nothing new in Africa. Various parties, white and black, have found ways to make money from the continent's people, awesome physical beauty, unique wildlife, and natural resources such as crude oil, diamonds, platinum, and gold.

Lust for gold spurred European exploration of Africa. Prior to the 16th century, most of the gold circulating in Europe came from sub-Saharan Africa and was brought by Muslim tribesmen from North Africa. In exchange, the Saharan tribes received European goods including weapons that they used to battle each other and the ethnic groups of sub-Saharan Africa. In the 15th century, the Portuguese decided to cut out the middlemen and sailed down the west coast of Africa, looking for the source of what was called the golden trade of the Moors.

Gold mining still goes on in Africa. South Africa is the world's leading gold producer. During the apartheid era, its white-run mines were known for their profits, harsh working conditions, and the tight control they exerted over their black workers, such as requiring them to live in single-sex hostels. That practice only changed after a four-day strike by some 90,000 miners in 2005, which was settled when the mining companies agreed to give workers a raise and to provide family accommodations for miners separated from their spouses and children.

The teenage men Randy Olson photographed in the northeastern part of the Democratic Republic of the Congo mining gold with a sledge hammer and chisel weren't working for a corporation. They were probably in the employ of a local warlord whose activities are financed by selling gold.

Mining gold is relatively benign work for young people in the Democratic Republic of the Congo. In 1997 war broke out in the region, largely over control of its natural resources. Children were active combatants. International organizations that monitor child labor estimate anywhere from 6,000 to 20,000 children served as soldiers, some voluntarily, others as conscripts.

The conflicts in many African nations make it hard to bring exploitation of children under control. Even worse, the strife cripples the future. Cultures such as the Dinka that have long been able to feed themselves and, in some cases, produced agricultural surpluses enabling them to become active traders and provide foodstuffs to neighboring tribes in exchange for a variety of goods and services, have become dependent on food supplied by relief organizations. Getting the food to them is frequently a logistical nightmare because of lack of infrastructure, corruption, banditry, and international indifference and inaction.

Such dislocations don't just destroy the possibility of meaningful work. They destroy the culture. Generations of children are raised far from the social, extended family, and community structures that supported their people's way of life. The connection to their homelands is lost. They don't learn the work that their parents and grandparents knew. They learn to wait and to suffer and to scrape by in a place far from home.

The world's work is to feed them. The wall of grain sacks Bruce Dale photographed may look bland and blank. But it represents hope that African men, women, and children can have peaceful lives in which work brings more than another day of existence. Lose that hope and we will have to suffer their children and their wrath to come unto us, one way or another.

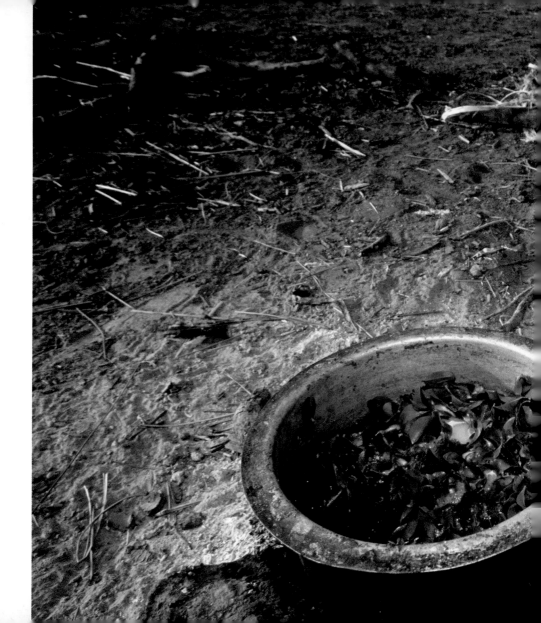

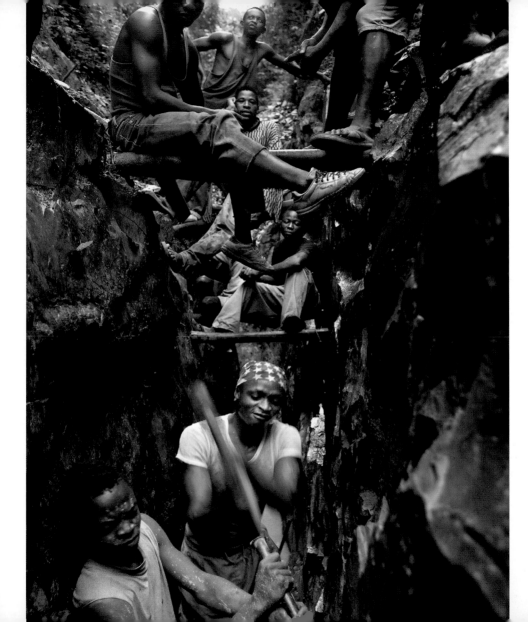

preceding pages:

RANDY OLSON

Dinka woman cooking leaves for meal, Ruwen County, Sudan
2002

RANDY OLSON

Youths mining gold, Democratic Republic of the Congo
2004

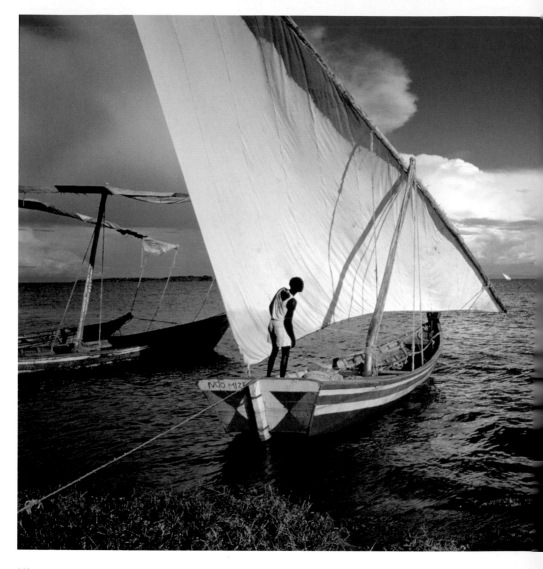

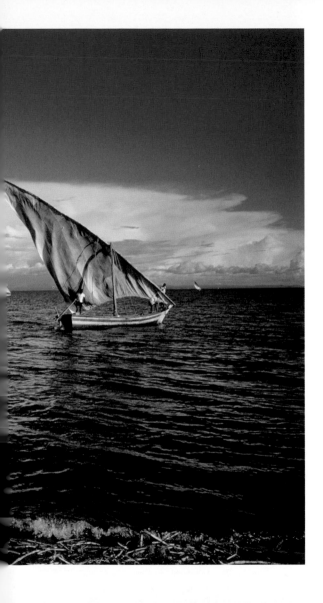

CHRIS JOHNS
Herero woman watching her Bushman servant iron, South Africa
2000

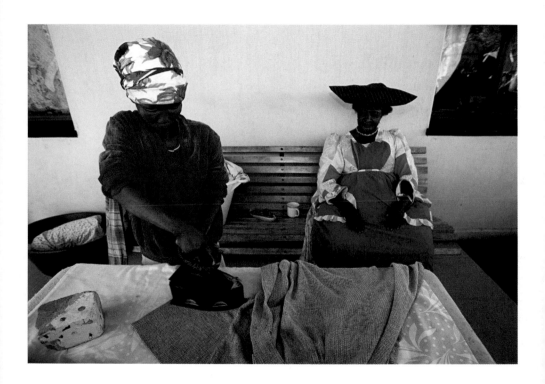

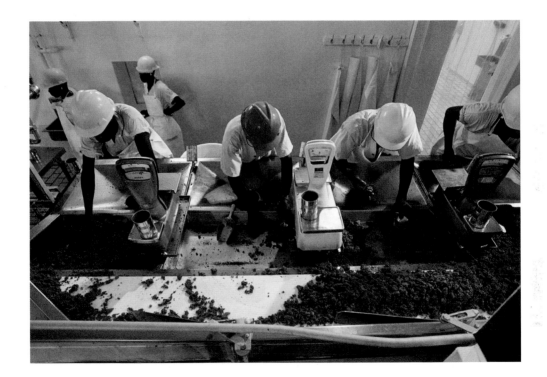

**TOMASZ
TOMASZEWSKI**

Repackaged milk for sale,
Soweto, South Africa
2001

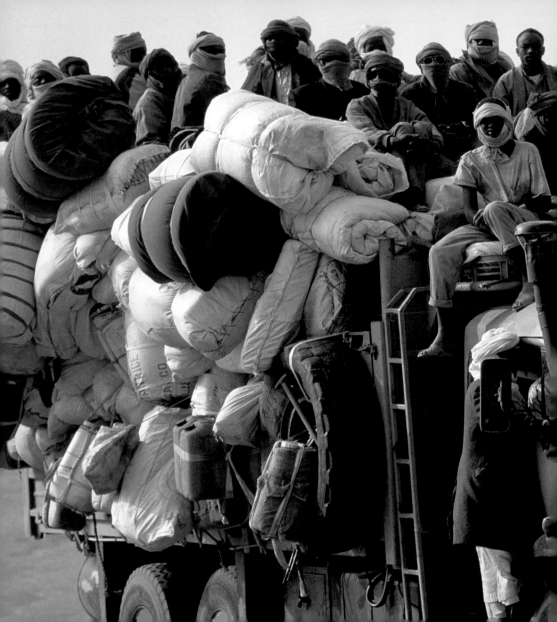

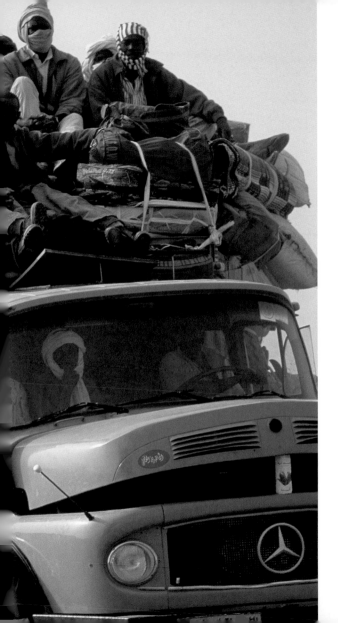

preceding pages:

GUGHI FASSINO
Fishing boats, Oueraka, Mali
1999

GEORGE STEINMETZ
Temporary workers returning
to Chad from Libya,
Faya-Largeau, Chad
1999

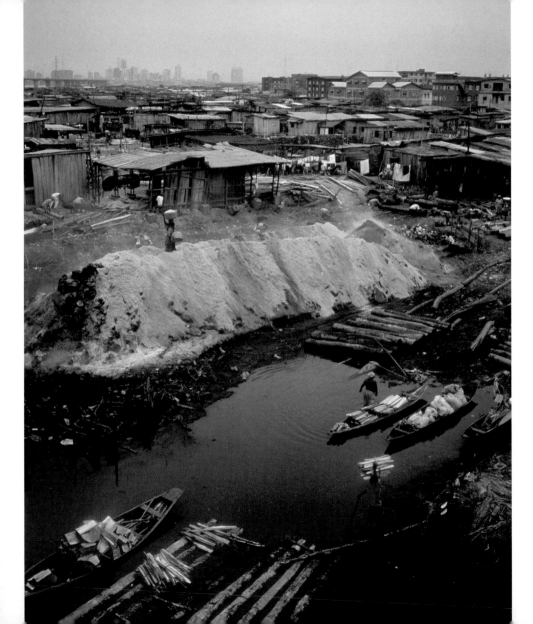

MICHAEL NICHOLS
Child carrying heavy load,
Republic of Congo
1999

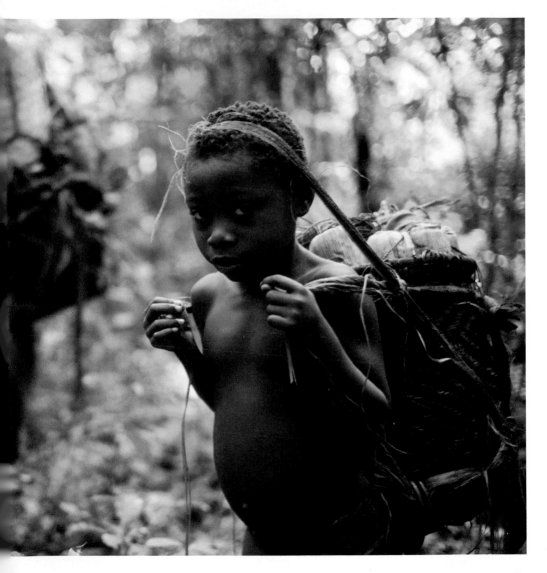

JAMES P. BLAIR
Timber poacher, Tai National Park, Ivory Coast
1983

preceding pages:

ED KASHI
Zulu field hand burning sugarcane field, Melmoth, South Africa
1997

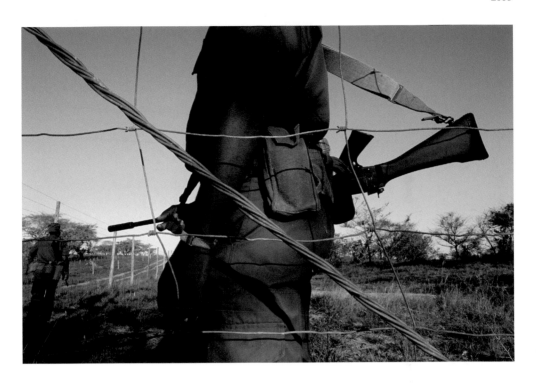

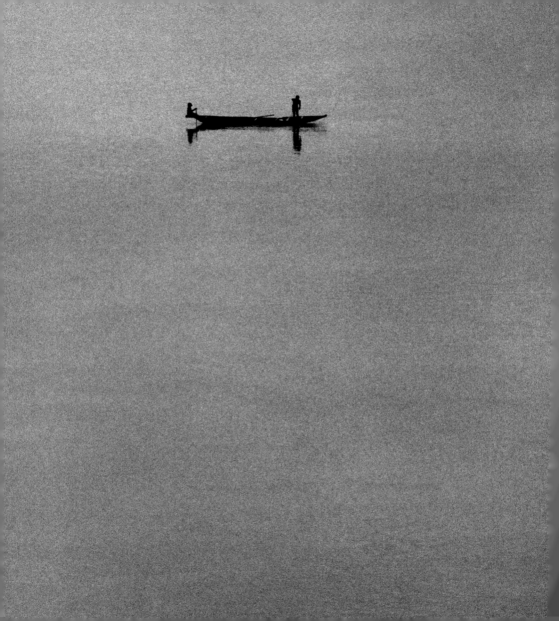

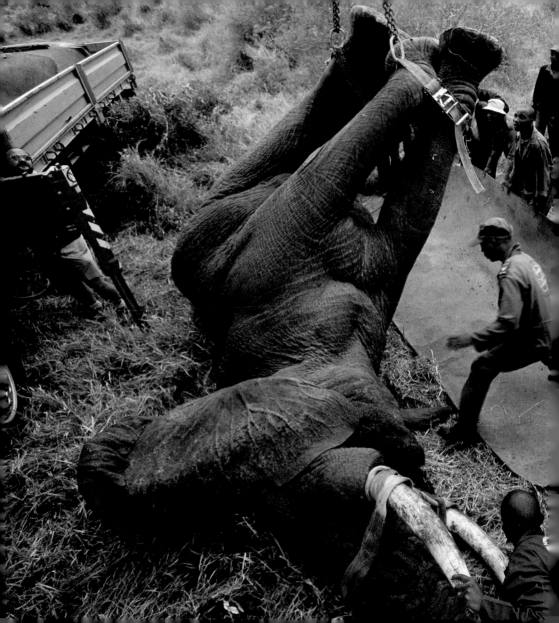

preceding pages:

MATTIAS KLUM
Fisherman on a quiet river, Nigeria
1999

CHRIS JOHNS
Preparing an elephant for transport,
Kruger National Park, South Africa
2000

171

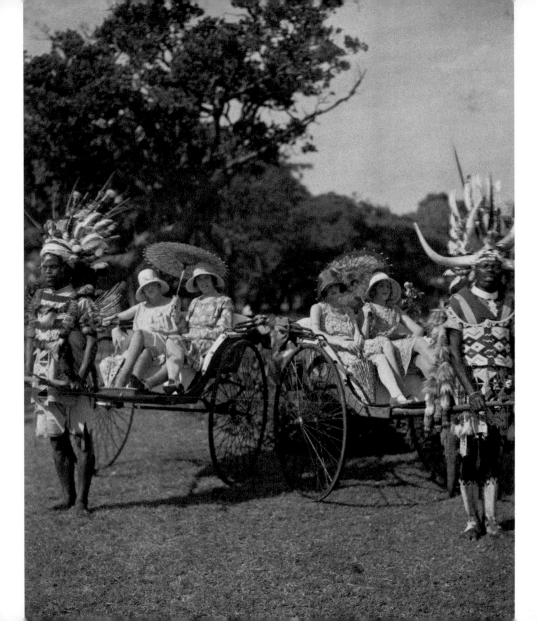

MELVILLE CHATER
Zulus pulling whites in pedicabs, Durban, South Africa
1930

MELVILLE CHATER
Women picking apples, Orange Free State, South Africa
1930

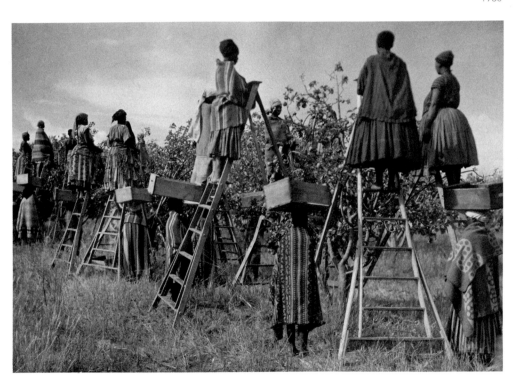

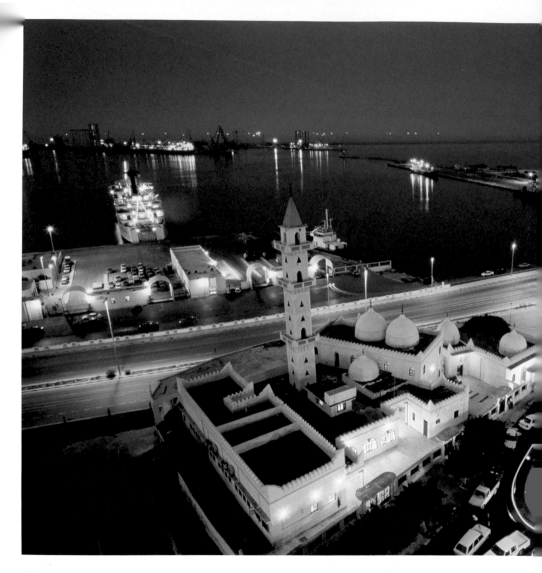

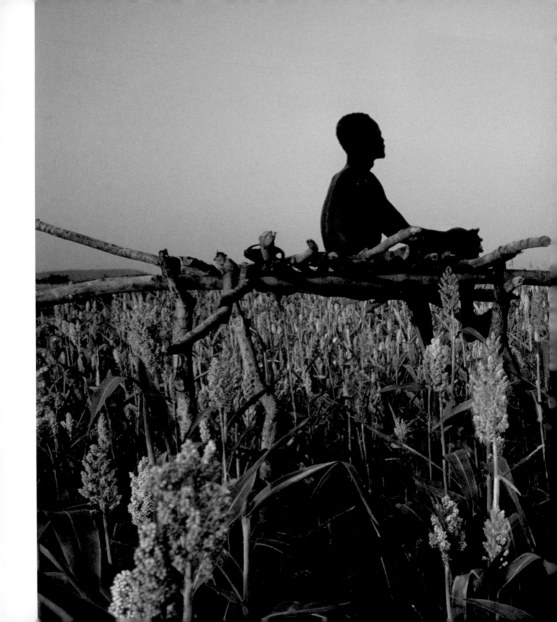

preceding pages:

ROBERT CAPUTO
Anuak farmer guarding
a sorghum field,
Upper Nile, Sudan
1982

ED KASHI
Longshoreman napping in a
heavy equipment machine,
Durban, South Africa
1997

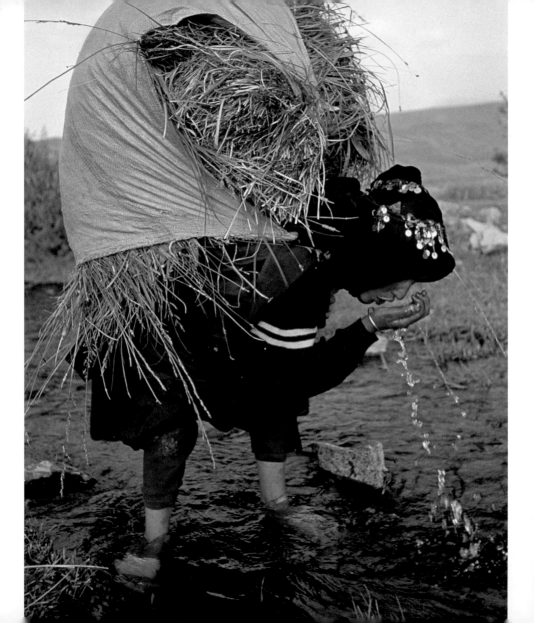

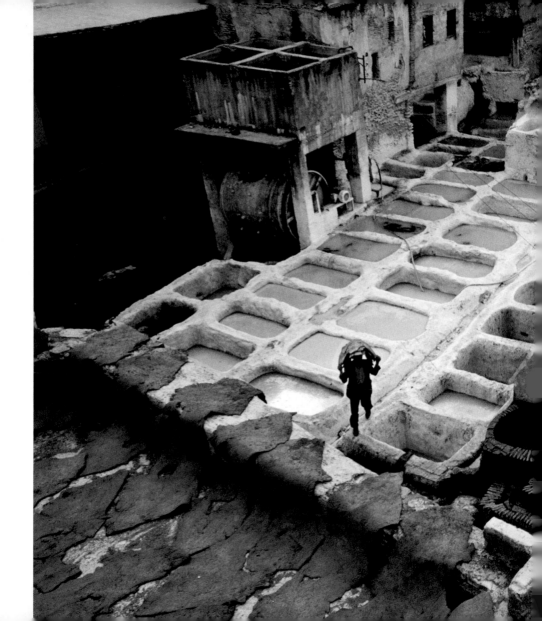

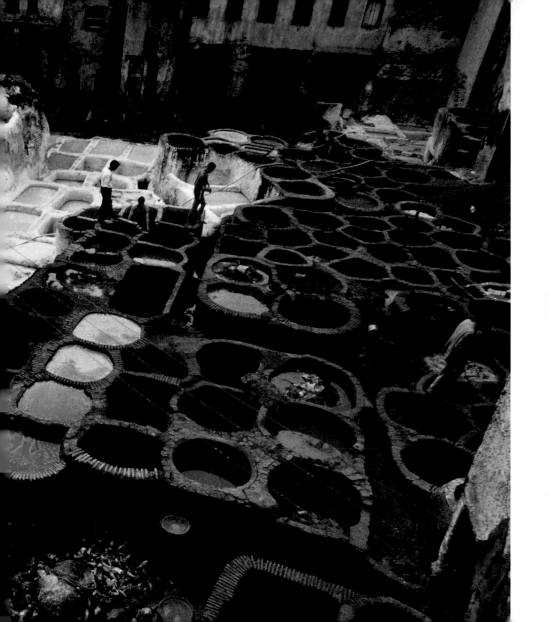

preceding pages:

JAMES L. STANFIELD
Tanning and dyeing, Fez, Morocco
1990

H. T. COWLING
Kikuyu women spreading coffee beans to dry, Kenya
1923

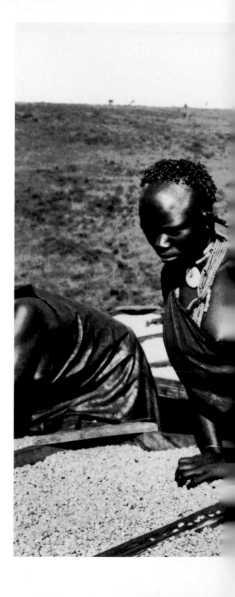

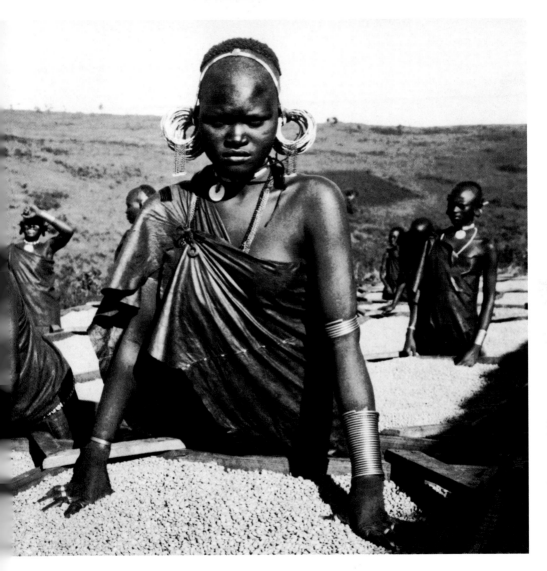

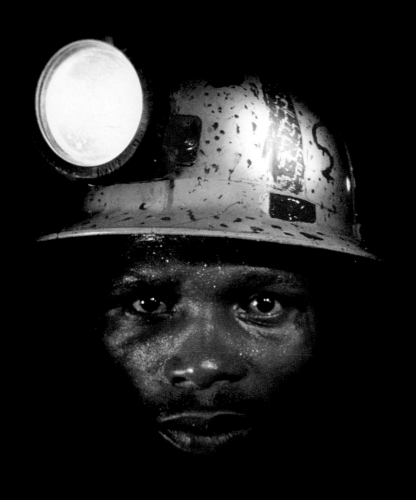

CHRIS JOHNS
Traders crossing South Africa-Mozambique border, Mbangweni, South Africa
2000

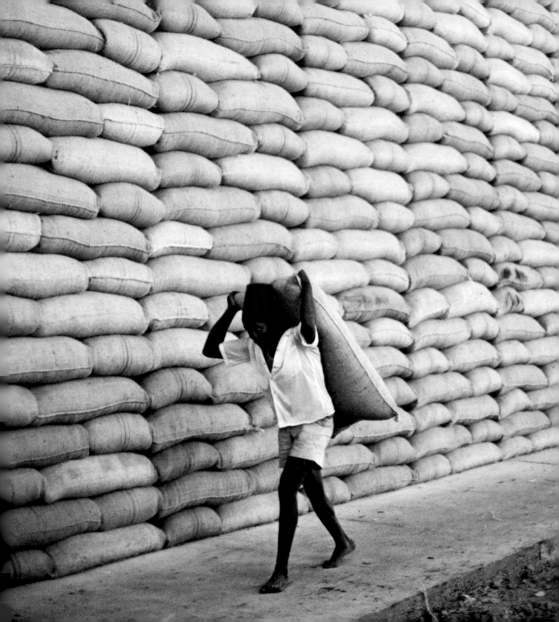

Extraction

FOR CENTURIES, PEOPLE HAVE DUG, DRILLED, AND blasted various ores and minerals out of the Earth. These have been used to make things ranging from gold jewelry to atomic bombs. Coal, for instance, is mined and burned to make electricity; oil products power vehicles, ships, and aircraft, and provide heat. Extracting these things is often tough, dirty work, requiring muscle and machines.

Extraction also takes place on the Earth's surface, where some poor people make a meager living mining the detritus of industrial society. In a slum in Dhaka, Bangladesh, James P. Blair photographed women and children recycling dry-cell batteries. Their method: hammering the batteries to pieces, discarding carbon, and saving tin, lead, and plastic. Unlike other miners depicted in this section, the grim-faced child staring from Blair's picture is surrounded by toxic substances but wears no protective gear. It is a haunting and horrible image. A child's body is being destroyed and his soul extracted by work requiring little more than desperate people and hammers.

MARIA STENZEL
Moving mountains of coal, laborers load boxcars in Ledo, India
2003

192

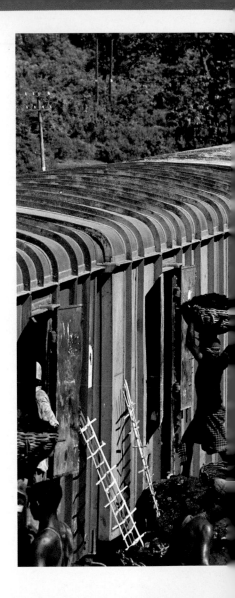

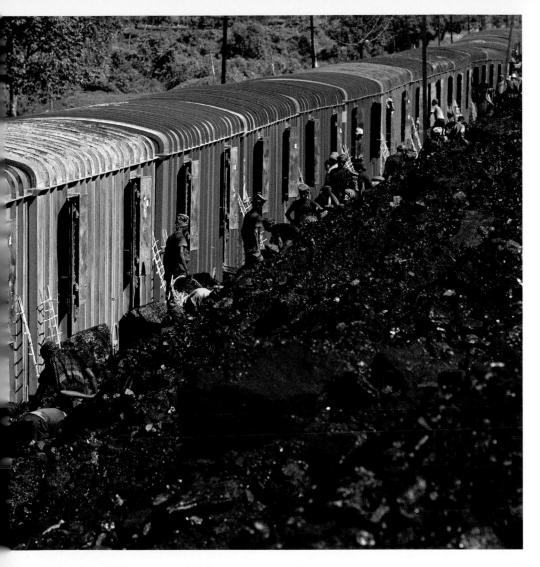

JAMES L. AMOS
Platinum miners riding bucket hundreds of meters to the surface, Rustenberg, South Africa
1981

opposite:

IAN BERRY
Pipe flaming on British Gas offshore platform
1999

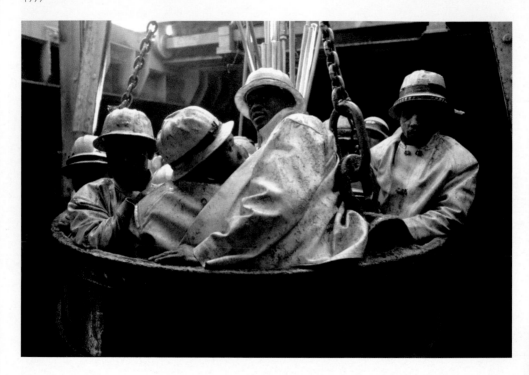

194

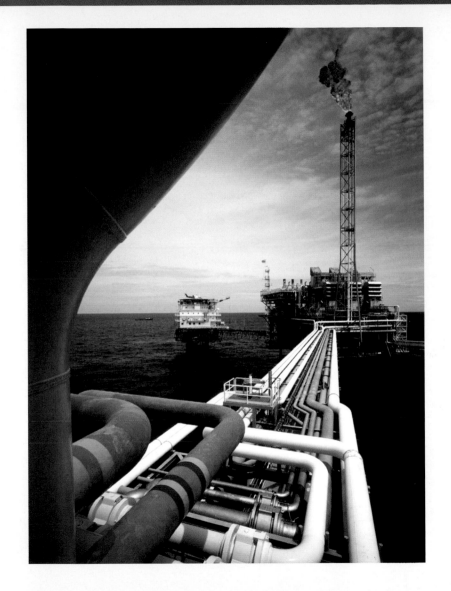

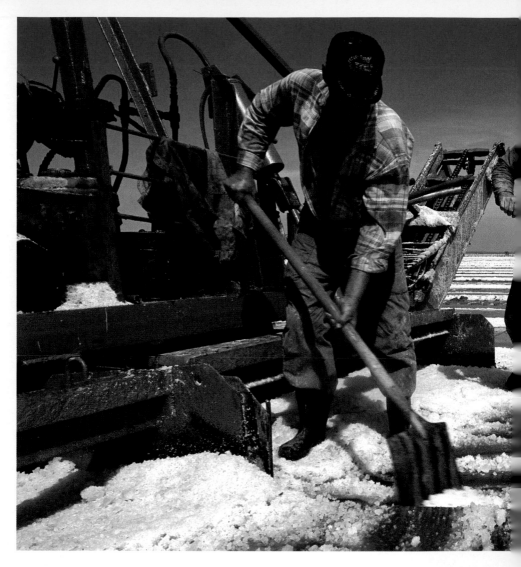

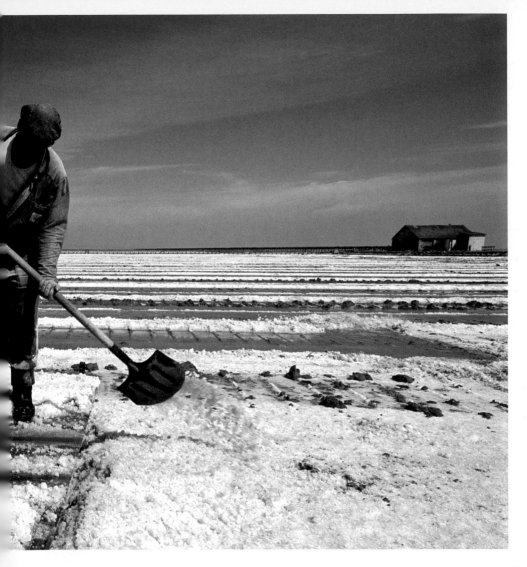

JAMES P. BLAIR
Children and women recycling dry-cell batteries by hand, Dhaka, Bangladesh
1991

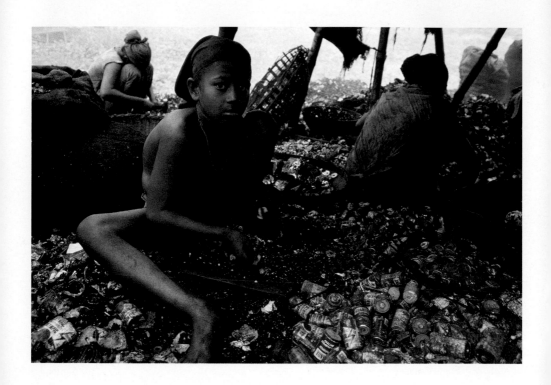

preceding pages:

SISSE BRIMBERG
Hot work in the salt fields of Crimea, Ukraine
1995

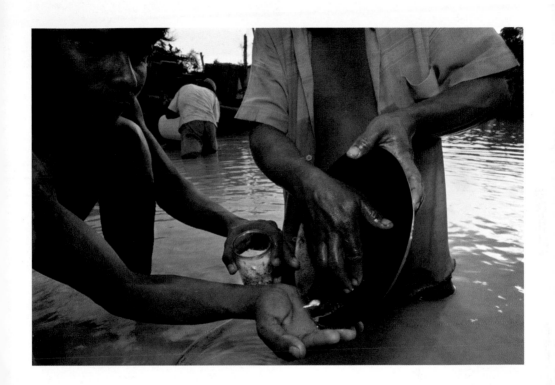

TOMASZ TOMASZEWSKI

Cramped miners using pneumatic drill in hot,
dangerous mine, South Africa
2002

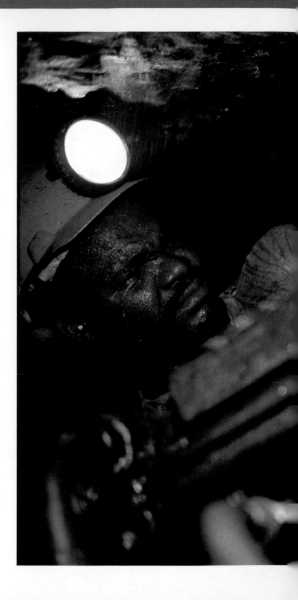

GEORGE F. MOBLEY
Lead mining with dual, automated drills, Viburnum, Missouri
1962

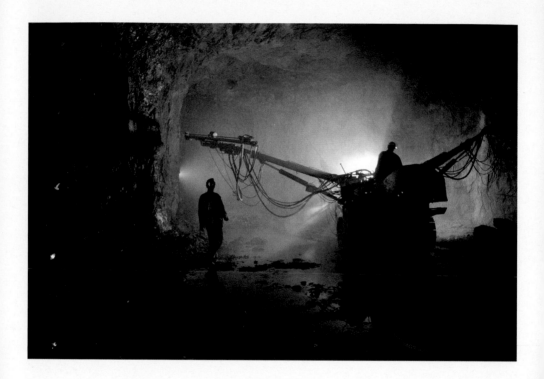

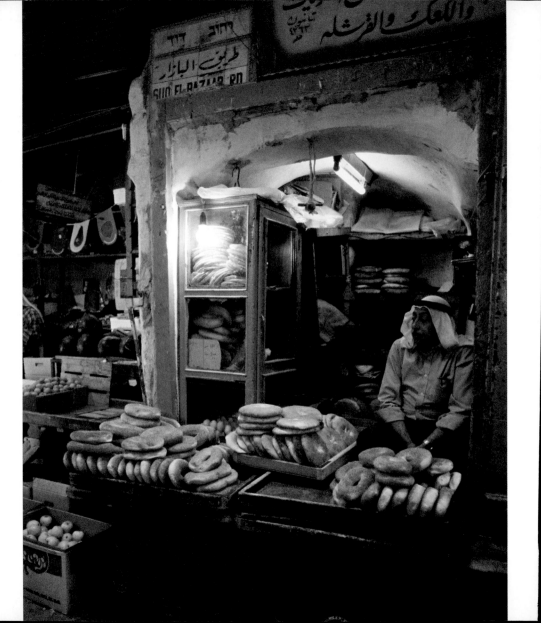

middle east

The photographs of the Middle East appearing so frequently in the Western mass media—grisly after-action images of suicide and roadside bombings; shots of combat troops, militia men, grieving families, and angry crowds—show the region as an arid, armed camp packed with religious fanatics willing to do anything in the service of their lords and leaders.

Within the confines of that stereotype, the main work of the Middle East is conflict, Muslims, Jews, and Christians engaging in an age-old round of strife over religion, territory, political power, and, more recently, the black lifeblood of the global economy: oil.

The images of war and terrorism that have emanated from the Middle East for decades are news but not new. Pictures of human beings killing, torturing, and maiming each other, ostensibly in the name of God, have been around for centuries. During the Thirty Years War, which wracked Europe in the first half of the 17th century, booklets and prints provided vividly detailed illustrations of the atrocities Catholics and Protestants perpetrated on one another. Those gruesome publications proved quite popular with the public.

Editors around the world have been feeding the mass market's appetite for pictures of mayhem ever since. The photos of strife in the Middle East, like their pictorial precursors, highlight the violence and its immediate aftermath, distilling time down to those moments when death is not just present but visible and visceral, emotions are raging, and daily life is disrupted.

Such images inflict a kind of blunt-force visual trauma to the viewer's central nervous system, pounding faraway horrors into our lives. Following the attacks by radical Islamic terrorists in Spain, Britain, Israel, Saudi Arabia, and the United States, it's a wonder that anyone who watched the news on television or saw the newspaper accounts ventured from their homes.

Yet, they do. Life goes on. People go back to work.

They do so for many reasons, such as mouths to feed, bills to pay, or force of habit. After every incident, no matter how horrible, the cameras leave and the living bury and mourn the dead and then go on about their business. Hatreds may fester, opinions may harden, revenge may be plotted, but every day, millions of folks in Egypt, Syria, Saudi Arabia, Israel, Yemen, and other parts of the Middle East go to their jobs as cooks, farmers, bus drivers, laborers, mechanics, merchants, teachers, soldiers, government bureaucrats, doctors, or physicists. Come evening, they go home.

We seldom see photos of that resurgent, ordinary life in the Middle East. The fact that Israel, for example, has a modern, high-tech economy and excellent educational system gets obscured by its political and military situation. At best, photos can show us facets of the lives and activities of individuals in Israel and other nations of the Middle East. Extrapolating from those, we get a sense of the people and their culture that can be compared and contrasted.

In the Middle East's case, however, comparing and contrasting is no simple matter. Westerners generally know little about the region. Very few of us have traveled or lived there. Fewer still possess even rudimentary knowledge of Arabic. In most Western countries, Middle Eastern history, culture, and religion are not taught in depth below university level, if they are taught at all.

On a person-to-person level, cultural interface is rare. Although people from the Middle East do emigrate to the West and large numbers of them now live in Europe, they often live in tight circles of kinsmen and countrymen, circles largely closed to outsiders. The West's most common point of connection with the Middle East devolves down to the gas pump, which dispenses fuel not understanding.

Meanwhile, the region's violence and political instability, and photographs of those things, domi-

nate the media. The pictures are so powerful and ubiquitous that they tinge even prosaic depictions of life in the Middle East with ominous portent. Reza's photograph of men unrolling rugs for morning prayers in Mecca, Saudi Arabia, or Richard Nowitz's shot of two Syrian men playing backgammon in Aleppo, are quiet, evocative pictures, showing routine aspects of Middle Eastern life. But because of the geopolitical situation, somewhere in the back of our minds we wonder if the people shown are would-be terrorists or if some fresh outrage is in the offing. As a result, ordinary life in the Middle East is degraded from the rule into the exception.

While the blazing oil wells Sisse Brimberg photographed in Kuwait in 1993, two years after the Persian Gulf war, remind us of the region's volatility, most of the photographs in this chapter are taken from the ebb and flow of normalcy. They present a more differentiated and nuanced picture of life and work in the Middle East, showing societies with deep historical roots and traditional values that are also struggling with the demands of modern life and surging population growth.

Work for many of the people in the Middle East is little changed from what it was when the world's first great civilization arose around 3300 B.C. in Sumer, or southern Mesopotamia, between the Tigris and Euphrates Rivers. Sumerian civilization developed on the marshy floodplains of the rivers' lower reaches and was based on agriculture. The Sumerians' prowess at growing cereal grains and other crops in the rich soils created by the rivers' annual floods produced an agricultural surplus. The abundant food supply allowed the population to expand and gather in villages and city-states with organized religious, social, and economic structures.

The Sumerians were eventually supplanted by Semitic tribes around 2000 B.C. But Sumerian civiliza-

tion developed a number of things still central to work as it is known today around the world, including writing—cuneiform script carved with a reed on clay tablets—record-keeping, the 24-hour day, the 60-minute hour, and the plow.

Then as now, the most important factor in Middle Eastern economic activity is not oil, but water, and the majority of the region's population works in agriculture, crowing crops and tending herds. Climate remains the most powerful determinant of life in the region. Compared to Europe or the Americas, the Middle East has precious little in the way of fresh water resources, arable land, forests, and natural resources other than crude oil.

Yemen, for example, has a total area of 527,970 square kilometers, none of which is water. Of its land, only 2.78 percent is arable. Yet some 21 million people live there, many of them working in agriculture or herding. It is a young population, with a median age of 16.54 years. Nearly half the people live in poverty. Yemen's per capita income is the equivalent of 800 dollars a year, making it one of the poorest countries in the Middle East despite the presence of oil. Some 370,000 barrels are exported daily, while proven reserves of 4.37 billion barrels are in the ground. While the oil industry does create some work, it has not been enough to transform Yemen into a prosperous place.

Finding work in Yemen is difficult. The unemployment rate is about 35 percent. Poverty and joblessness, particularly among young men, are problems throughout the region and are seen as prime contributors to the rise of radical Islamic movements. Throughout history, people lacking jobs, education, or prospects have often turned to religion to give their lives purpose and meaning It is worth noting that Islam's spiritual appeal is quite similar to one of the main tenets of many Western religions, namely that

through faith and religious practice, the individual can have a direct, personal relationship with God.

The world's major religions also encourage individuals to establish a direct, personal relationship with work, which is held up as a virtue. The Islamic work ethic holds that life without work is meaningless, and the individual is obligated to engage in economic activities. As formulated by the German sociologist Max Weber in his treatise *The Protestant Ethic and Spirit of Capitalism*, the Calvinistic strain of Christianity had a spiritual inclination towards capitalism because the faithful believed work and financial success were means to achieve not just personal goals but eternal salvation.

A work ethic, however, doesn't guarantee anyone a job. Neither does religious affiliation, although according to some socioeconomic studies Islam may be less conducive to the development of free-market economies than other religions because Muslims have traditionally had low regard for private property, economic competition, and women in the work force.

Whether that is true or not—one could argue that such attitudes have national or tribal rather than religious roots—anyone looking at photographs of work in the Middle East soon notices that very few women are depicted. Those that are depicted rarely seem to be looking at the camera.

But that can also be said of many of the Middle Eastern men we see in this chapter. The pictures all seem somewhat distanced, as if the photographers didn't dare get too near their subjects. Even in close-up shots, such as Robert Azzi's photo of Prince Salman, the governor of Riyadh, Saudi Arabia, listening to a whispered request from a petitioner at a *majlis*, or audience, all eyes avoid the lens.

This sense of remove may be rooted in the pictorial traditions of Islam, which discourages depicting people and forbids any depiction of the Prophet

Muhammad. That approach differed significantly from the practices of the region's earliest cultures. Sumerian art was the first in history to feature realistic likenesses of human beings in statuary and paintings. Egyptian art expanded and refined that tradition. In Western art's evolution, religion and pictures of people, particularly Jesus Christ and other Christian figures, were seminal. Secular portraiture and depictions of ordinary folk at work and play have been accepted for centuries.

Except for pictures of violence, photographs of the Middle Eastern countries do not have the intense closeness of Western photography, where news organizations have adopted many of the tropes of fine art, such as the brutally intimate shots of people and subcultures pioneered by artists such as Diane Arbus or Larry Clark. Were a Saudi, Iraqi, or Syrian artist, male or female, to produce such work, the societal and familial consequences would probably be dire. That doesn't hold true for Israel, a more open society whose pictorial traditions are rooted in Western culture.

Many of the pictures in this chapter show ordinary people at work, doing things that have been done for centuries. A bored shopkeeper sits behind a counter filled with bagels in Jerusalem. A Syrian man hammers a pattern into a copper bowl, yet another craft invented by the Sumerians. Customers examine the goods at a broom shop in Syria. Such scenes reflect the special place commerce and craft hold in Islam. Before he became a prophet, Muhammad was a merchant named al-Amin ("the trusted one"). Then one day he went to a cave on Mount Hira near Mecca and was transformed into the Messenger of Allah.

When the photos show elements of modernity, the tension between the West and the Middle East enters the scene. It is there in the grim faces of the Iranian clerics taking computer-training class in Qom

or in the Western-made automatic weapons carried by the security guards racing through the Saudi sands in a pick-up truck. Such images raise the question of whether change in the region, change instigated largely by Western influence, is for better or worse.

How the struggle in the Middle East between its ancient, traditional ways and the West's cultural and economic juggernaut will be resolved, no one knows. There are times when the situation seems hopeless, the differences intractable, the cycle of violence eternal.

But of all the pictures in this chapter, I keep coming back to two in particular because there is something ameliorative in them. During the Iraq War in 2003, Alexandra Boulat photographed an Iraqi woman in the ruins of a Baghdad building, possibly her family's home, weaving reeds into a mat. A little girl stands in the background, watching the woman work.

Weaving reeds is a handicraft that has been passed down over millennia in the Middle East. The first homesteads in ancient Mesopotamia were built on platforms of reeds and mud long before Christ, Muhammad, or Moses appeared. The Iraqi woman, dressed from head to toe in black, in accordance with tradition, reminds me of the *Trümmerfrauen*, the women who worked picking up the ruins of Germany's bombed cities after World War II, brick by brick. I don't know if she is a Sunni or Shiite Muslim or what her politics or familial connections might be. But I admire her for going about the work of living. That's the human spirit, rising from the ruins as it has so many times in so many places.

The second photo was taken by Gerd Ludwig in Al-Sharam, Yemen, where he witnessed a young woman, Salaam Moth, 25 years old at the time he took the picture and working as a nurse and midwife, vaccinating a young boy. With assistance from the International Fund for Agricultural Development, a United Nations agency, she had turned a room in that village into an infirmary, providing care for all the villagers, regardless of their social or economic standing.

Salaam Moth's eyes are not on her work or averted. They look straight into Ludwig's camera. It isn't the hostile stare one sees so frequently on the faces of Arabs on Western television or in newspapers. It is a fierce look radiating pride and exhilaration. She isn't doing the work women traditionally perform in Arab cultures, such as taking care of the household, raising the children, fetching water and firewood, or helping raise crops and tend animals. She is using her knowledge and training to improve the health and life of the boy, his family, and the community in which they live.

In the Western world, there is a perception that women in Islamic cultures are powerless. Yet, Ludwig's photo shows a female health-care worker proudly exercising her power to better villagers' lives and doing that within the context of her religion and her community's traditions. Moth and the women holding the boy are veiled. They wear the *sharshaf*, a black garment covering them from head to feet, typically worn by women in Yemen's northern highlands. From beneath it, Moth's white sleeve shines like a beacon in the night.

To people living in societies where decent medical care is readily available, vaccinating children is routine. In the context of Yemeni life in the early 21st century, it represents a significant evolution in health care and in the country's social development. The average life expectancy at birth of a boy in Yemen is currently about 60 years, of a girl about 64 years. That's more than a decade shorter than in most Western industrial nations. Female nurses giving Yemeni village children a chance at longer lives doesn't mean they'll be happy, productive, or peaceful people. But it is a cause for hope.

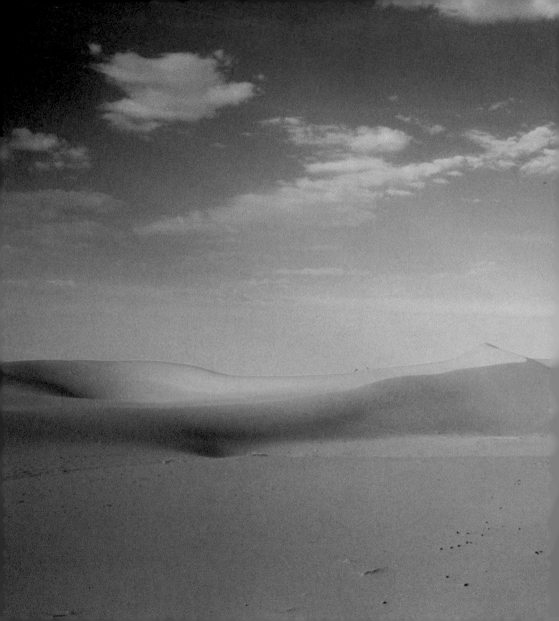

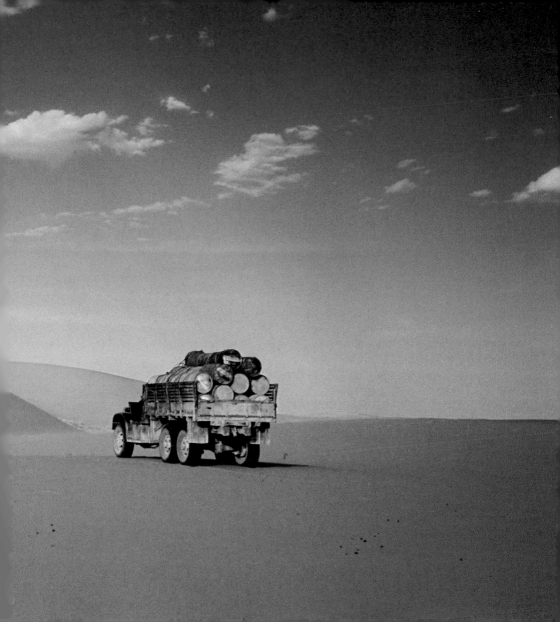

preceding pages:

MAYNARD OWEN WILLIAMS

Transport across Ad Dahna's red sand desert, Saudi Arabia
1945

REZA

Fishermen on the Nile River, Cairo, Egypt
1991

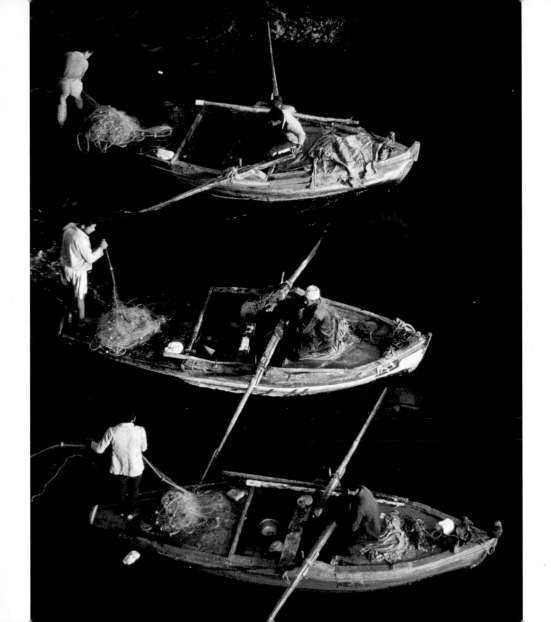

REZA
Carriage on Jeddah's waterfront at sunset,
Saudi Arabia
2002

REZA
Security detail driving across desert in Saudi Arabia
2003

opposite:

SISSE BRIMBERG
Oil fires still burning after the Persian Gulf War, Kuwait
1993

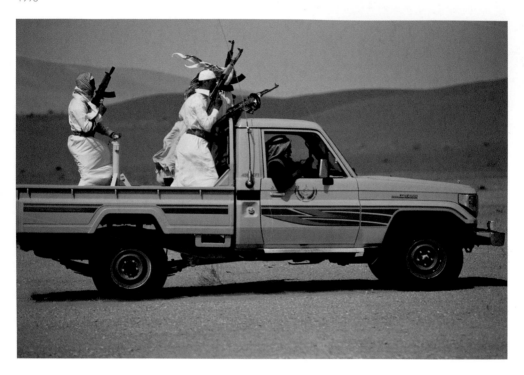

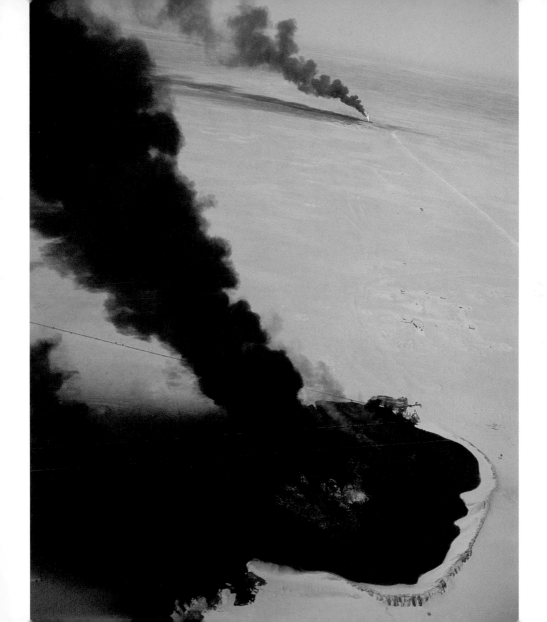

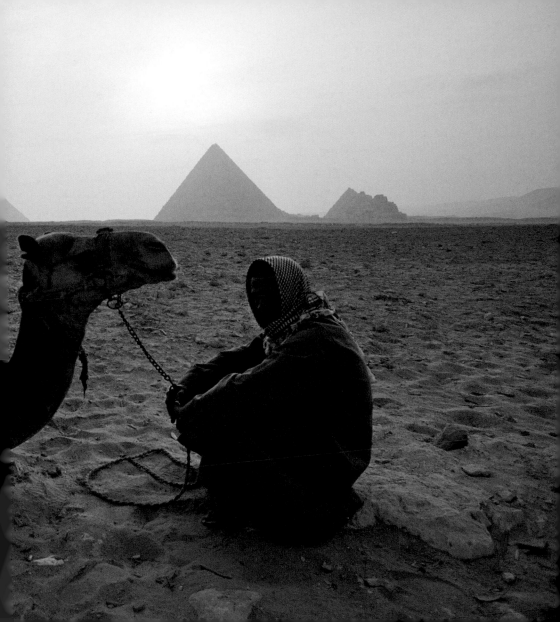

RICHARD NOWITZ

Men laughing in a café during the Khan el Kalili Bazaar in Cairo, Egypt
1998

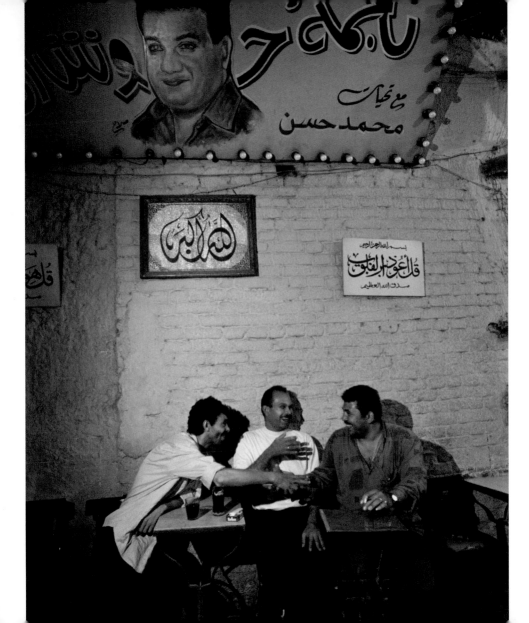

ROBERT AZZI
Prince Salman, governor of Riyadh,
listening to petitioner, Saudi Arabia
1980

following pages:

STEVE McCURRY
Women collecting clover for cattle,
Republic of Yemen
1997

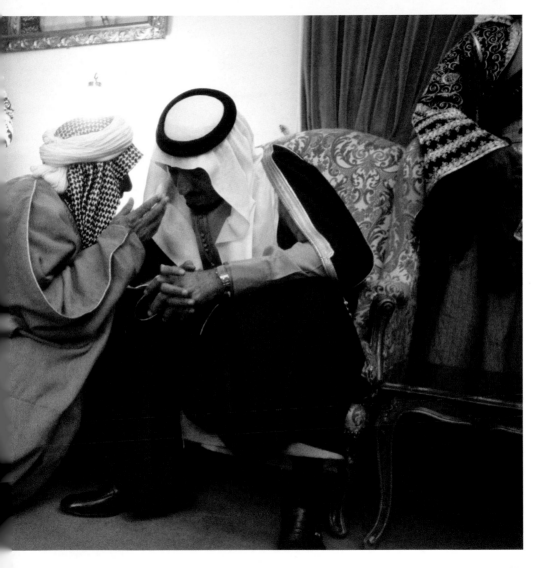

223

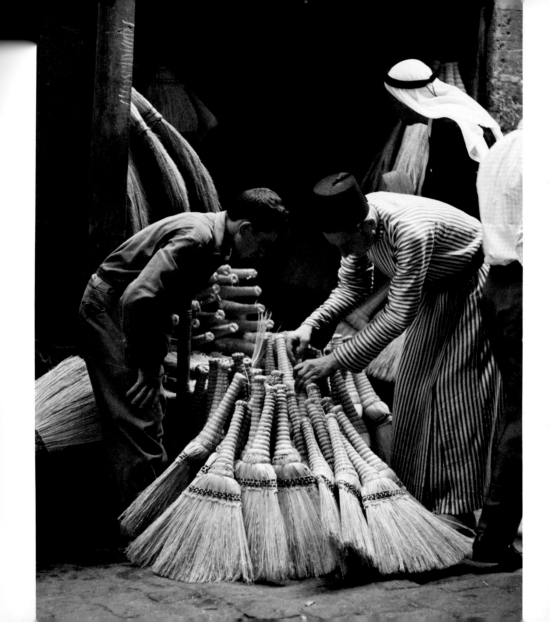

opposite:

FRANK AND HELEN SCHREIDER
Selling brooms and sweepers, Aleppo, Syria
1966

ALEXANDRA AVAKIAN
Clerics studying at computer school in Qom, Iran
1998

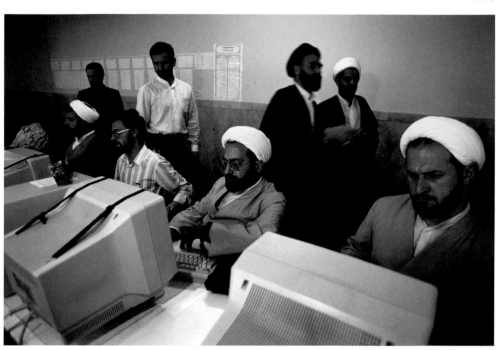

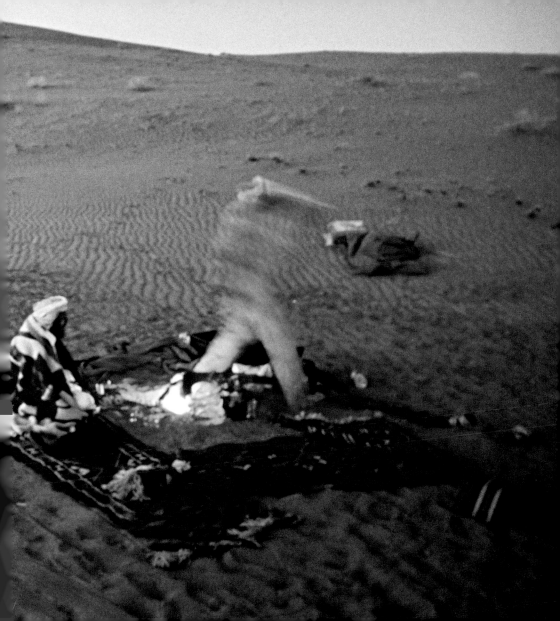

preceding pages:

GEORGE STEINMETZ
Bedouins sitting on rug by fire, Rub' al Khali (Empty Quarter),
Arabian Peninsula
2004

MICHAEL S. YAMASHITA
Dhows beached near Ra's al Hadd in Oman
2004

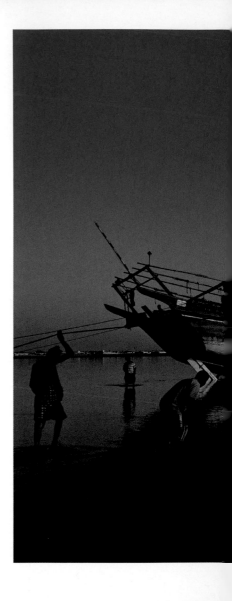

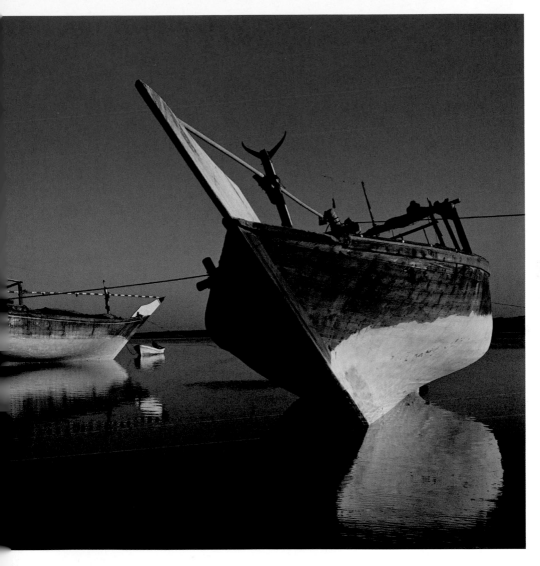

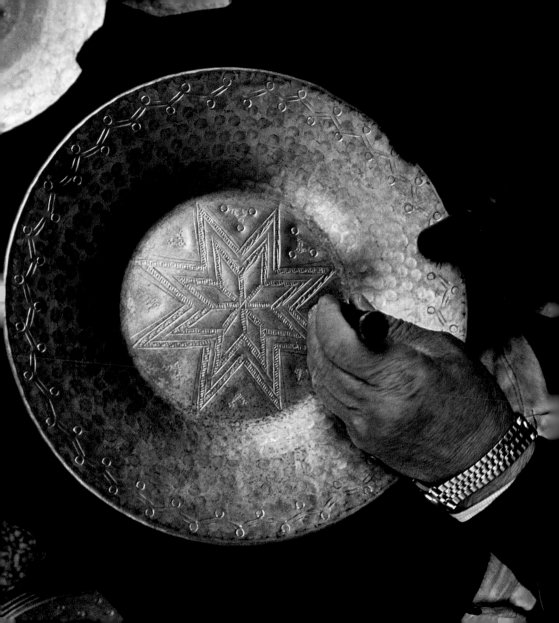

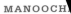

MANOOCH

Ancient work: Syrian man hammering
design on copper bowl, Qatna, Syria
2002

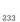

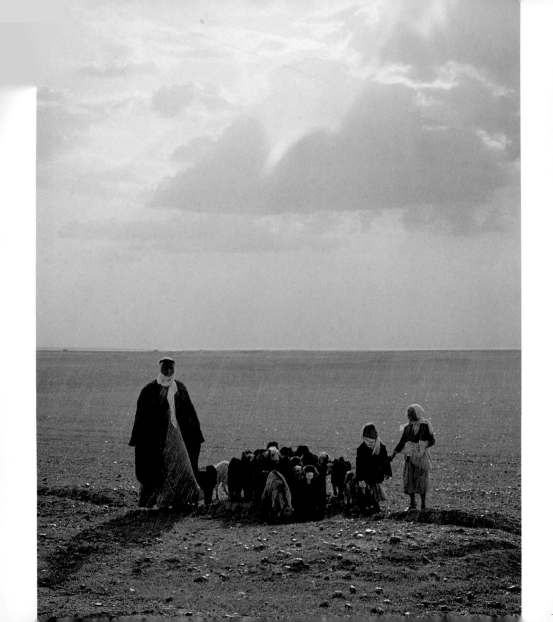

DEAN CONGER
Herding goats, Al Ragga, Syria
1965

KENNETH GARRETT
Egyptian woman making bread loaves in traditional manner, Quarna, Egypt
1997

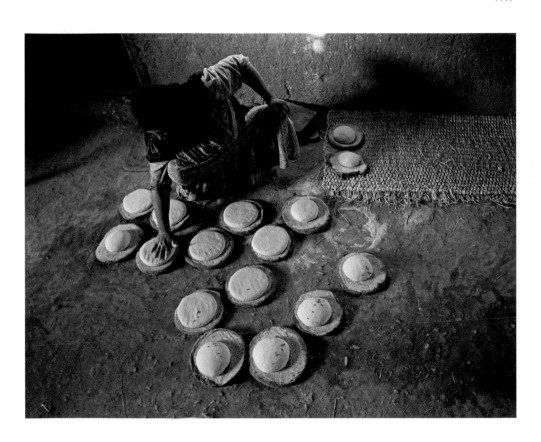

ALEXANDRA BOULAT

Woman weaving reeds into a mat during Iraq war, Baghdad
2003

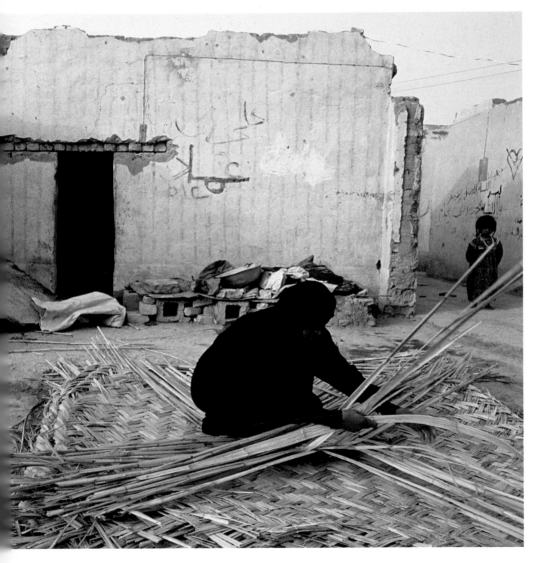

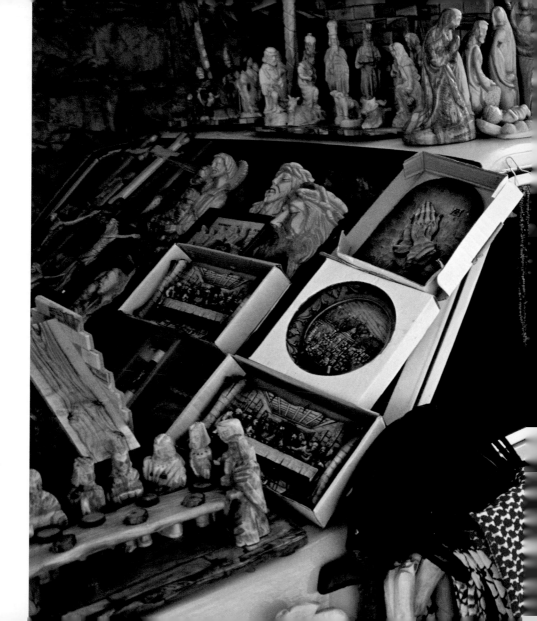

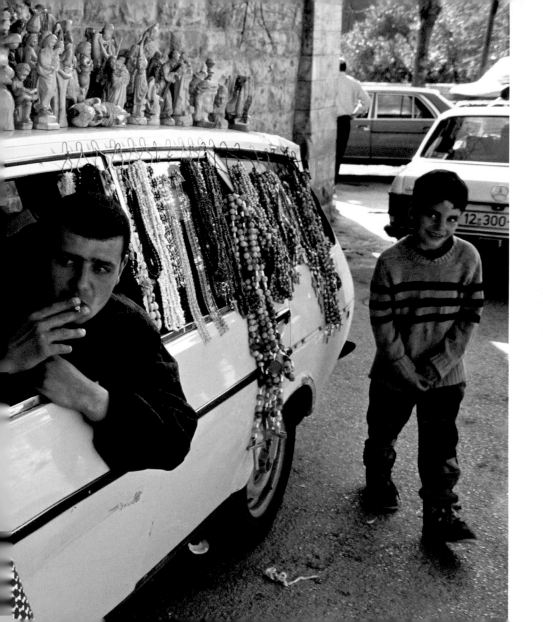

preceding pages:

ANNIE GRIFFITHS BELT

Selling religious wood carvings to tourists,
Mount of Olives, Jerusalem, Israel
1995

REZA

Men unrolling rugs for morning prayers,
Mecca, Saudi Arabia
2002

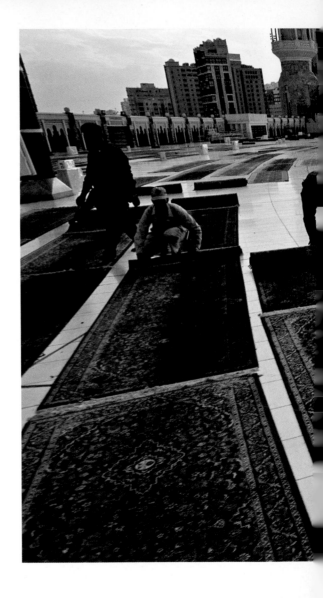

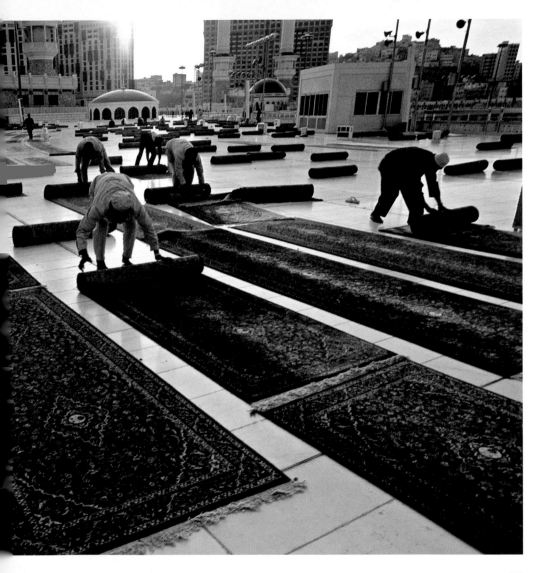

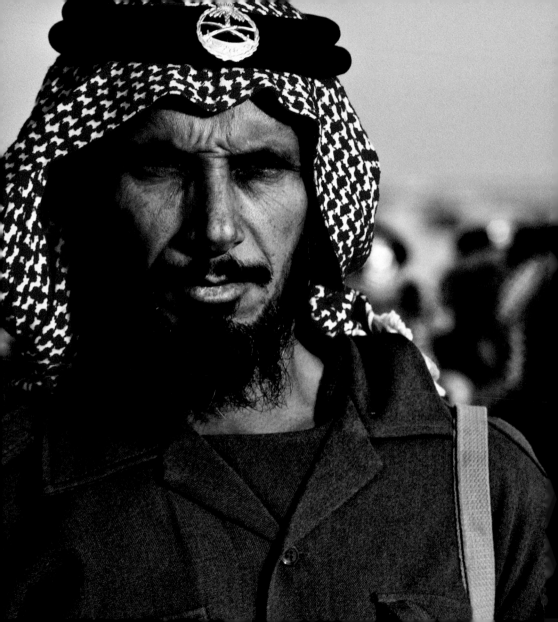

ROBERT AZZI
Bedouin national guardsmen,
Saudi Arabia
1980

GERD LUDWIG

Nurse-midwife Salaam Moth vaccinating a young boy, Al-Sharam, Yemen
2002

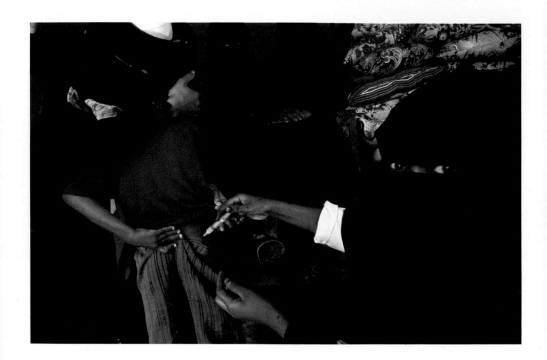

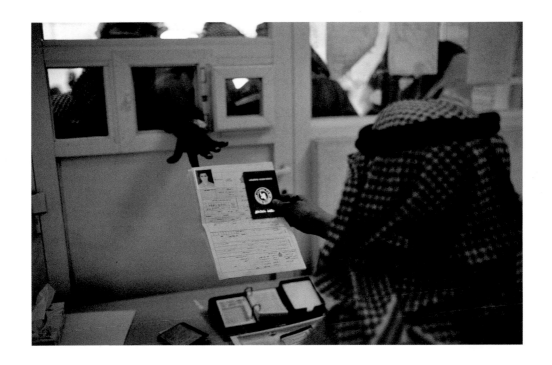

americas

erched atop a scaffold of slender tree trunks joined with bark strips, a man fishes using a net stretched between two long poles. The scene is reflected in the still water as a negative image rendered in softly shimmering shades of silver, black, and gray.

Edward S. Curtis's photograph of a Hupa Indian man fishing is a classic piece of visual poetry taken from the tribe's everyday life in the early 20th century. Although the picture was shot in 1923, the man's fishing method and dress are probably little changed from Hupa ways of previous centuries. Curtis's meticulous composition gives this timeless work a tranquil beauty that evokes the contemplative state fishermen have experienced through the ages.

Curtis specialized in photographing North American Indians. Aesthetically pleasing as many of his pictures are, they also depict the folkways of various tribes at a time when those ways of life were being altered or destroyed by the onslaught of European culture. While his photos are now treated as fine art, their greatest value may still be sociological and historical. They are cultural portraits that give us a sense of how indigenous Americans looked, lived, and worked for generations before Europeans came to America.

The photograph taken by Joel Sartore of repair gang workers in a giant shovel or "dipper" at the Bingham Canyon Copper Mine in Salt Lake City, Utah, also has cultural implications. Sartore shot the stern-faced trio of mineworkers clad in yellow slickers standing on the dipper's teeth, while one of their colleagues grins through a joint in the massive arm above their heads. The three pose with the resolute body language of white-hat heroes facing down outlaws in some Western film.

The machine isn't cast as the bad guy, although it's big, scary, and wearing some black. That color dominates the picture plane and it is not warm and soft as

in Curtis's photo. This black is ominous and deep, looming behind the main figures like some portal to a monster's maw. The animate impression is heightened by the rectangular headlights on either side of the bucket, burning like malevolent eyes.

The picture highlights the immense size and power of the shovel by using people to provide a sense of scale, a splash of contrasting color, and a means of beckoning us to imagine ourselves in their place. There's nothing gentle or contemplative about this earth-chewing colossus. It's the embodiment of contemporary North American industrial culture as a gigantic beast controlled by men.

What links these two pictures and many of the others in this chapter is the nature of the work. The Hupa fisherman and the Utah mine workers are engaged in the ur-American task of exploiting nature's bounty. This has been going on since the first Mongoloid peoples crossed over from Asia to North America sometime between 10,000 and 70,000 years ago and began migrating south.

The original hunter-gatherers who came to the world's last uninhabited continent were presumably drawn by its abundant game, fish-filled rivers and seemingly endless space. In such a place, the work of subsistence was relatively easy. If the subsisting got tough, the tough, and anyone else who could, moved on. There was plenty of room to roam.

Mobility would become another common thread running through the history and pictures of the Americas. In the present day, North and South America are highly mobile societies. People routinely go where the work is. Sometimes, their company sends them to a place. Or a better job presents itself elsewhere and they go there. This mobility has increased as the nature of work has changed. Over the past 50 years, the American industrial sector has waned. More people work with their minds, rather

than their bodies. Computers and cell phones have also made many types of work quite portable, enabling latter-day hunter/gathers working in advertising or investment banking to ply their trades from their homes or coffee shops.

That wasn't an option when tribal hunters were gradually migrating to and settling in many parts of what are now North, Central, and South America, from Alaska to Patagonia and from the Pacific to the Atlantic Ocean. Various cultures arose and declined in this vast area, including the Maya, Inca, Aztecs, Anasazi, Hopewell, and others.

Like all American cultures their economic basis was the exploitation of the continents' wealth of natural resources. The basic work involved in doing that has changed little from prehistoric times. Fishing, hunting, gathering, farming, logging, mining, quarrying, brick making, transport, and trading continue to this day in various forms throughout the Americas.

The early cultures were not literate, so there are no written records of what their peoples thought and felt about their lives and work. What we know of them comes from studying the prehistoric ruins of their cities, dwellings, sacred sites, and art. Many of the structures were remarkable engineering achievements, especially considering the work involved. Raw materials, such as timber and stone, required for a pueblo or pyramid often came from miles away, were transported without draft animals or wheels, and shaped without metal tools. Given those disadvantages, places like the city of Teotihuacán in Mexico, built around A.D. 500, are monuments to human will and muscle.

The remains of these societies are, in essence, visual images—frescoes, carvings, and sculptures—two- and three-dimensional pictures. Like Curtis's and Sartore's photos, they tell us something about the times, the people, and the way they lived. Since the ruins are our only guide to the past, we have little choice but to trust what experts say their pictorial language tells us.

That is a paradox since Western culture has never really trusted pictorial language, preferring words and numbers. This disdain for visual imagery has deep, historical roots. Plato, in his *Republic*, wrote that music was necessary for the education of heroes because it introduced humans to the mathematical order and harmony of the cosmos, things that transcended the sensory realm, and, thus, could be trusted. But he described fine arts, particularly painting, as suspect, because they tied man to illusory images.

Ancient Greece also provided a classical illustration of Plato's concern about illusion. According to the Roman author Pliny, Zeuxis, a fifth-century Greek artist, made a picture of grapes so realistic that birds came and pecked the painted fruit. The account of this incident sparked an eternal debate over verisimilitude in art. Depending on one's point of view, the birds' action is either proof of the painter's genius and the deceptive nature of art or convincing evidence that birds and viewers are easily duped.

Judging by the actions of the European explorers who probed the interior of the Americas in the 16th and 17th centuries and cast their eyes on the painted fruit of native culture, easily duped seems more likely. The explorers weren't looking for mere subsistence. They were seeking fame by claiming new territories and subjects for their sovereigns. They looked at the indigenous cultures' building prowess, art, and jewelry and concluded that somewhere the natives must be hiding enormous wealth, specifically gold.

Prompted by rumors and greed, various Europeans, including Sir Walter Raleigh and Francisco de Orellana, led expeditions into Central and South America seeking El Dorado, an entire city said to be made of gold

and ruled by a king coated daily in gold dust. Orellana and his cohorts were the first Europeans to float down the length of the Amazon River, passing through what we now know is a region possessing an incalculable wealth of flora, fauna, and natural resources. But they found no city of gold.

Nonetheless, El Dorado proved to be a lingering myth and the search for it an enduring allegory for life in the Americas after the arrival of European colonists. Regardless of their place of origin, the colonists and later immigrants came seeking something: land, wealth, escape, adventure, a fresh start, a better life. The colonists brought their beliefs and ways of life, their skills, trades, work methods, and attitudes toward work.

English Puritans, for example, brought to the Massachusetts colony their work ethic, which held that work was a calling and success in work a way of serving God. They also introduced to the Americas the use of child labor to manufacture textiles. To a contemporary Western sensibility, employing a workforce of children may seem like the rankest sort of exploitation. But it still goes on in other parts of the world and was tolerated in parts of the United States until banned by Federal legislation passed in 1938.

Photography, particularly by Lewis Wickes Hine, was instrumental in abolishing the practice. Hine was born in Wisconsin in 1874, and studied sociology at the University of Chicago, Columbia University, and New York University. That led him to photographing immigrants arriving at Ellis Island, in New York harbor. In 1908 he went to work for the National Child Labor Committee, photographing children working in textile mills, mines, and factories.

Hine's photographs were unprecedented. Never before had pictures, whether as fine art, illustration, or documentation, addressed a social issue with such blunt emotional force. Children were photographed where and how Hine found them, working in miserable, dirty jobs for pennies a day. There is no gloss, artifice, or romance in his photos, just pain, numbness, and resignation. Yet, they are undeniably magnetic.

The three little girls wearing grimy dresses worked as oyster shuckers in South Carolina. Their hands look cramped and raw. They stare into the camera with blank, sullen faces. So does the girl standing between the rows of machines she tends in a thread mill. There is no trace of youthful vigor or high spirits. These are kids reduced to near-automatons.

When Hine would ask the foremen or owners what the children he photographed were doing in the workplace, he was often told they were visiting their mothers or had simply wandered in, tried their hand at some task and kept coming back for more. That may even have been true in some instances. But none of the children were working for fun or to answer a calling or serve God. For whatever reason, they were there because they had to be.

People are at the center of almost every Hine photograph, understandably so since work is a human activity. His genius was in presenting not just children, but adults in the bleakness of their actual circumstances, and understanding how the camera could highlight that harsh context to great effect. Two long rows of machinery flank the girl in the thread mill and Hine turns them into barriers delineating an endless, soul-crushing path to nowhere. The mill becomes a life sentence for the child. No one with a conscience can look at that without feeling pain.

Banning child labor didn't end the pain associated with many kinds of work in the United States, it transferred it to an older segment of the workforce better able to bear it. Studs Terkel addressed the pain of work in the first lines of the introduction to his oral history, *Working*: "This book, being about work, is, by its very nature, about violence—to the

spirit as well as to the body. It is about ulcers as well as accidents, about shouting matches as well as fistfights, about nervous breakdowns as well as kicking the dog around. It is, above all (or beneath all) about daily humiliations. To survive the day is triumph enough for the walking wounded among the great many of us."

There is nary a photo in *Working*. People from every walk of life talk about their jobs, what they do, how they do it, and, most important, how they feel about it. Most of them, just as Freud suggested, do not derive much satisfaction from their work. Some flat-out hate their jobs. They work to support their families, to maintain their lifestyles, to survive. But we never see what Terkel's working folks look like, never gaze straight into their faces the way we do with Hine's subjects.

Maybe that's a good thing. In a photo, someone who says their job makes them sick and sad might appear smiling and happy. We're all conditioned to smile for the camera and, as viewers, many of us have been duped before into pecking at painted or wax fruit. On the other hand, a photo could make it easier for some readers to empathize with the people in Terkel's book.

So which do we believe, the words about work or the pictures? The answer is both, if we read the pictures as carefully as the words. Take Gerd Ludwig's photograph of a man picking flowers in California's Imperial Valley. On the surface, it's all about beauty. The sky is blue, the field a vast sea of purple, white, and green, glowing in the sunlight. It's easy to imagine how fragrant the place must have been.

On reflection, a different story emerges. When we buy cut flowers, we don't think much about where they came from. We care about how they look and smell, and what they cost. But people planted, nurtured, picked, packed, and shipped them.

The man in Ludwig's picture is part of that c[...] He is paid to pick flowers, which may end up in a v[...] gracing a restaurant or a living room. Like the peop[...] in *Working*, we don't see his face or hear his thoughts. But the picture tells us a lot about him. He's in a hurry, not stopping to pose. His right hand is picking a flower, while his left arm cradles those he's already bundled. Since he isn't wearing gloves, his hands must be calloused. The hat and long sleeves protect him from the sun.

In all likelihood, he is paid by the bunch, meaning what he earns depends on how fast he works, how many bundles of flowers he can pick and deliver during a day. In a photo, the flowers weigh next to nothing. What he has on his shoulder probably weighs at least 20 pounds. Stooping, pulling, bundling, lifting, carrying, over and over throughout the day. That's his work. His workplace is beautiful but if it has a bathroom, it's well hidden.

Elsewhere in America, billions of dollars are changing hands on the capital markets, and people wearing nice clothes are sitting in air-conditioned offices, working on their computers, communicating with their colleagues and clients by email. The flowers on their desk or conference table look and smell beautiful.

No one is lobbying Congress to ban flower-picking by consenting adults. The work isn't pleasant or easy, but someone has to do it since the machine that can judge when a flower is ready to pick and can pluck and pack it with care hasn't yet been invented. That's the way it is in the Americas. The pictures may look pretty, but our culture still knows how to exploit natural bounty and people the old-fashioned way.

preceding pages:

ARTHUR ROTHSTEIN
"Steam shovels, Cherokee County, Kansas"
1936

JACK DELANO
Daniel Anastazia, blacksmith's helper, Rock Island R.R., Blue Island, Illinois
1943

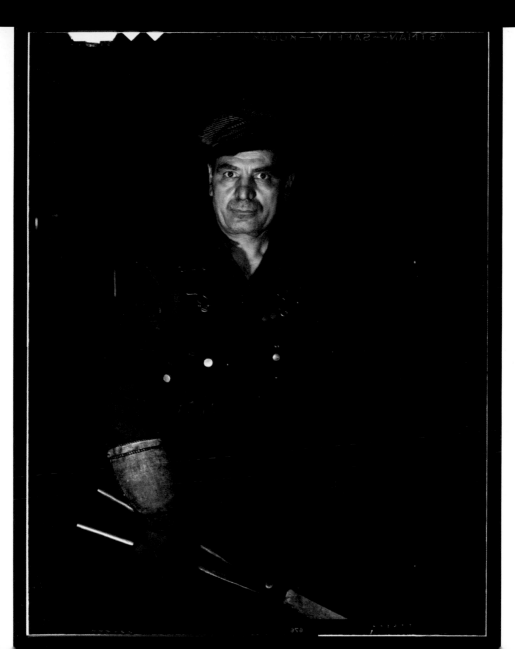

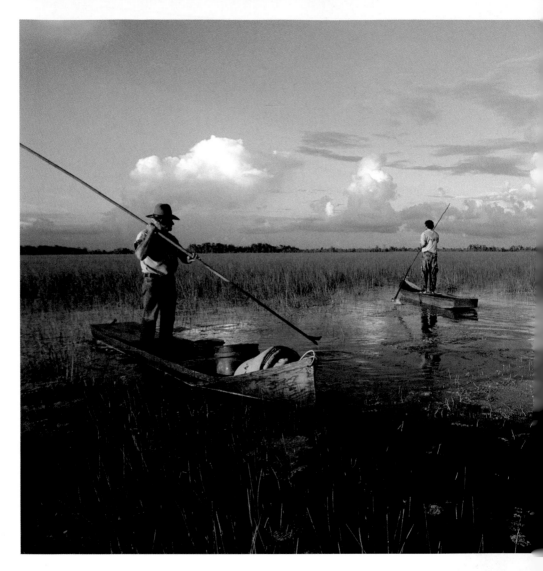

CHRIS JOHNS

Poling through Everglades National Park's
development-threatened lowlands, Florida
1993

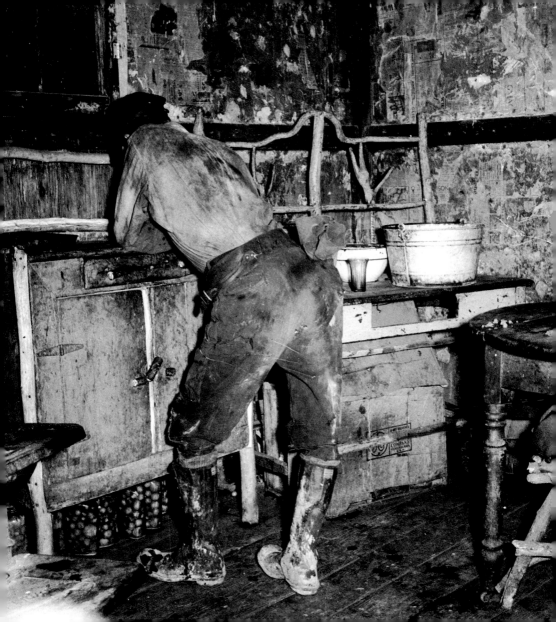

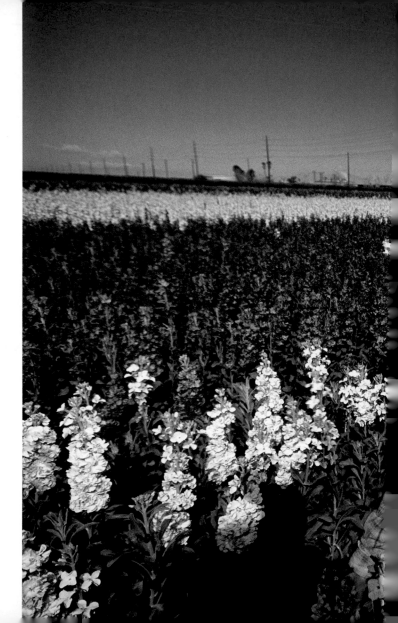

GERD LUDWIG
Migrant worker picking
flowers, Imperial Valley,
California
2003

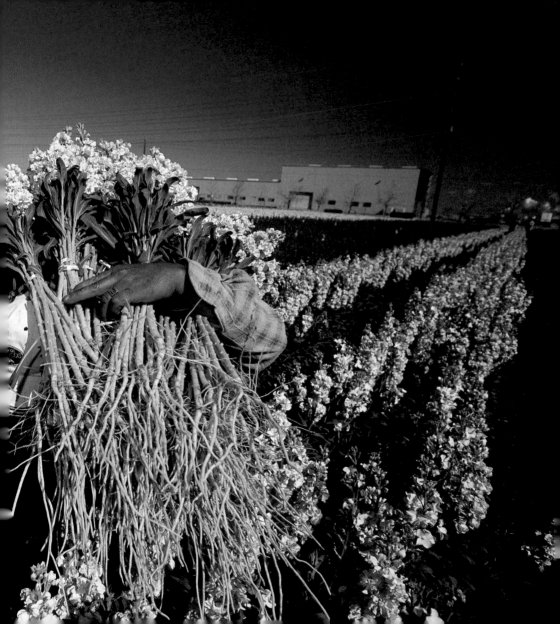

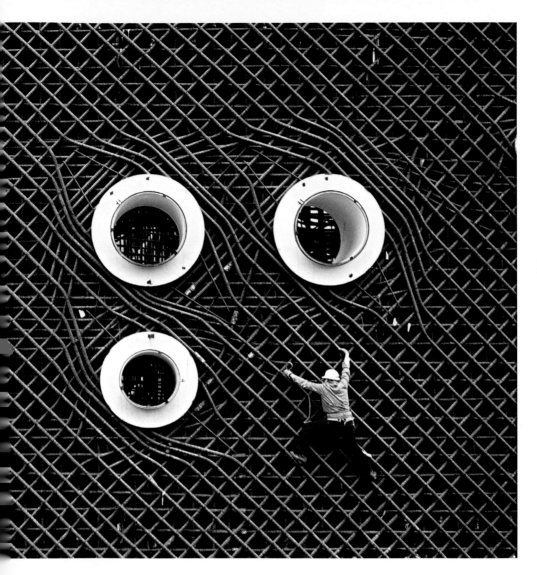

preceding pages:

ROBERT MADDEN

Spot-checking welds,
Hanford nuclear plant
construction, Washington
1981

JOEL SARTORE

Drilling for natural gas,
Rifle, Colorado
2004

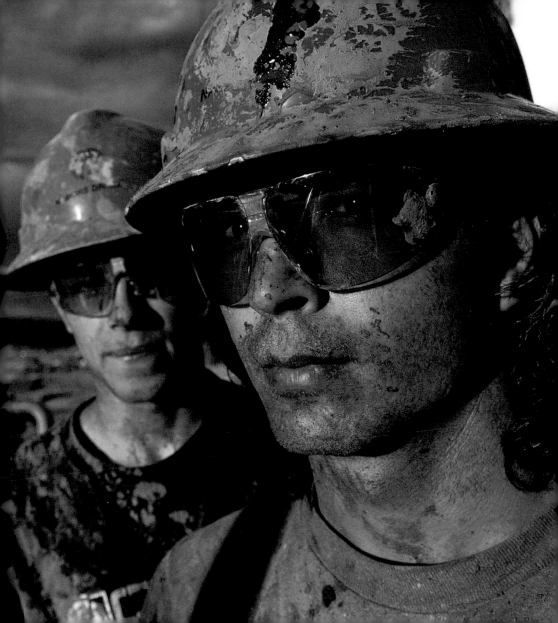

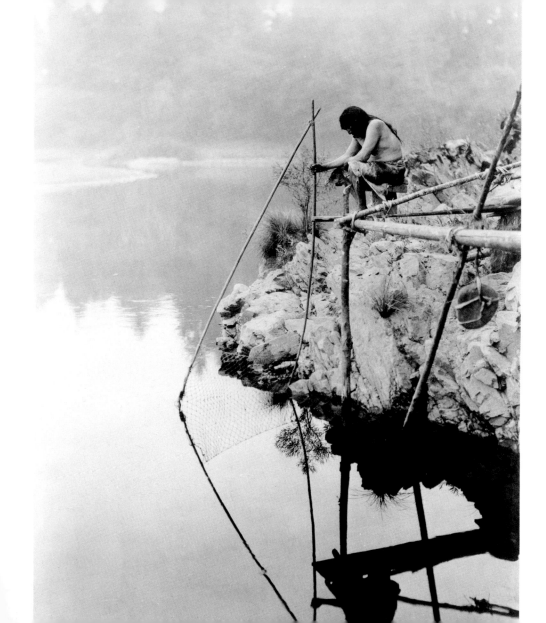

MARIO TAMA
Guarding Grand Central Terminal,
New York City
2005

preceding pages:

GERD LUDWIG

Mother brushing child's teeth
with river water, Aramira, Brazil
2002

JOEL SARTORE

Aymara woman herding llamas,
Atacama Desert, Chile
2001

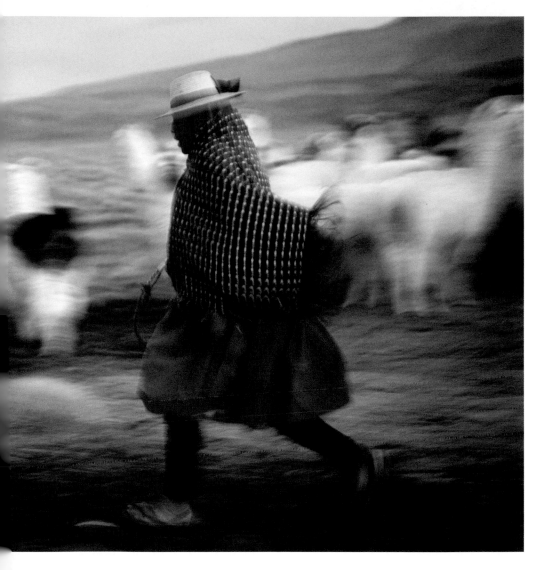

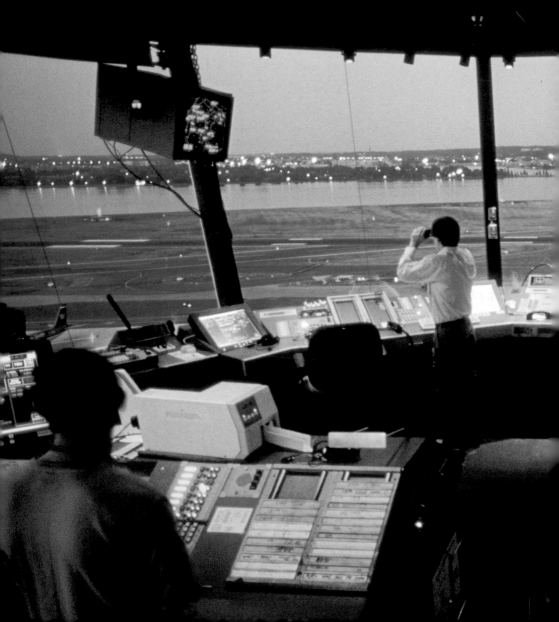

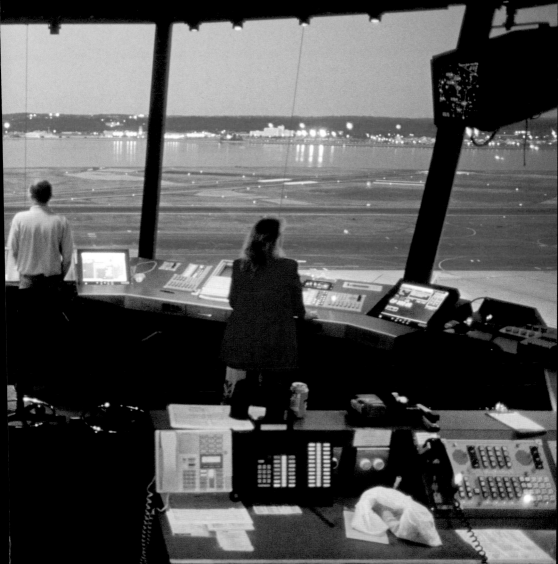

preceding pages:

GEORGE STEINMETZ
Air traffic control,
Reagan National Airport,
Washington, D.C.
2002

JOEL SARTORE
Giant shovel, Bingham Canyon
Copper Mine, Salt Lake City, Utah
1995

following pages:

STEPHEN FERRY
Kogi women washing tunics in
Sierra Nevada de Santa Marta, Colombia
2004

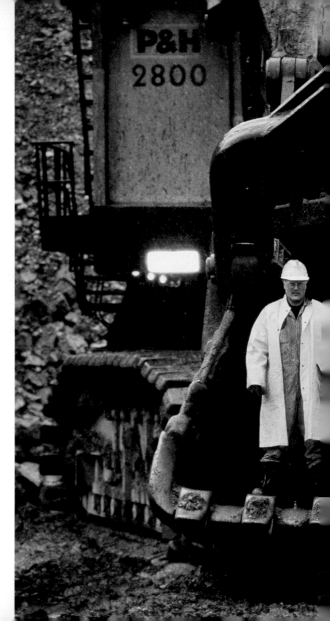

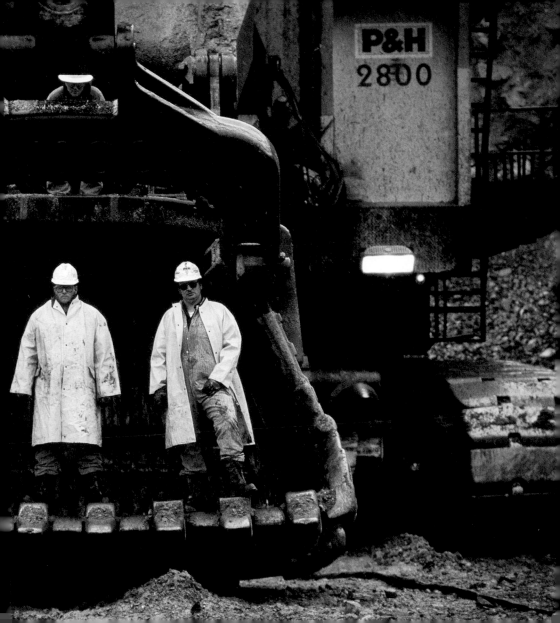

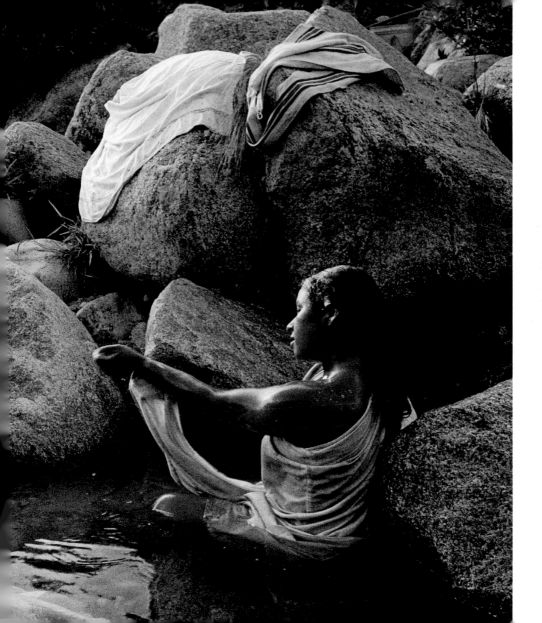

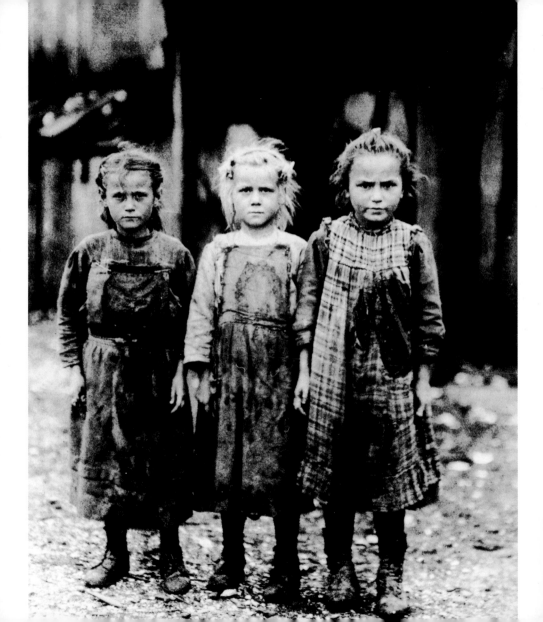

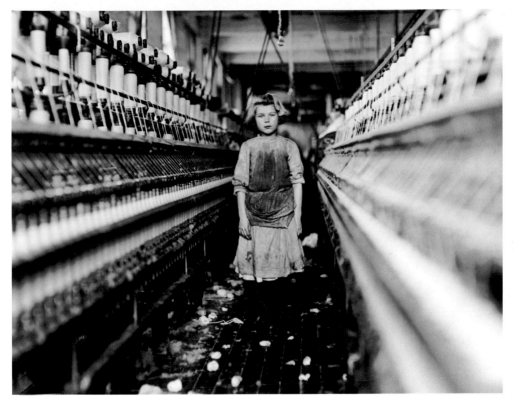

LEWIS WICKES HINE
Young girl working in cotton mill, Augusta, Georgia
1909

opposite:

LEWIS WICKES HINE
Young oyster shuckers, Port Royal, South Carolina
circa 1909-1932

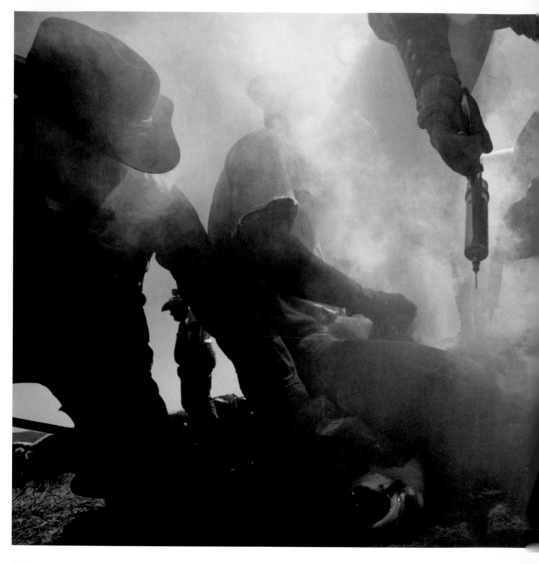

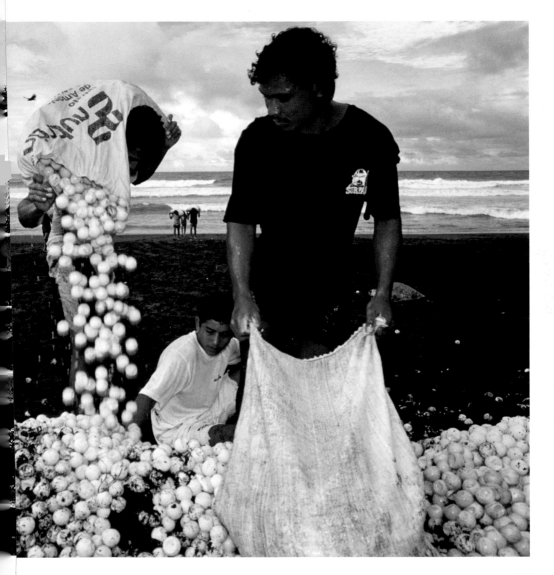

JOE RAEDLE
Working and paying to play:
Woman and slot machine,
Hollywood, Florida
2004

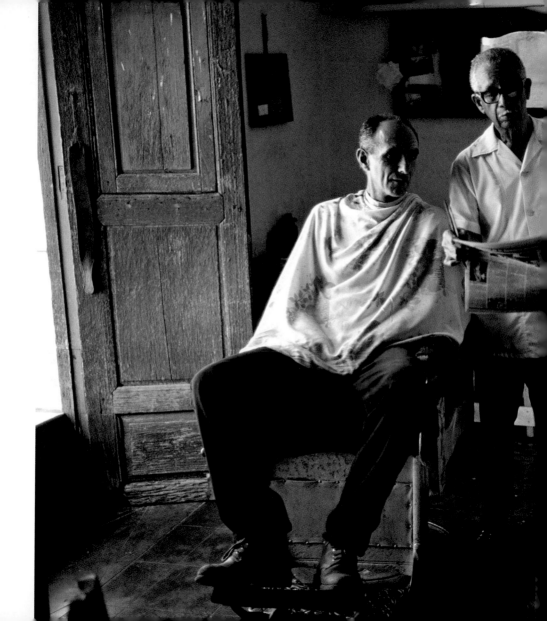

preceding pages:

DAVID ALAN HARVEY
Cutting hair: work as social interaction, Cuba
1999

JACK DELANO
Drilling rock, Fort Loudon Dam, Tennessee
1942

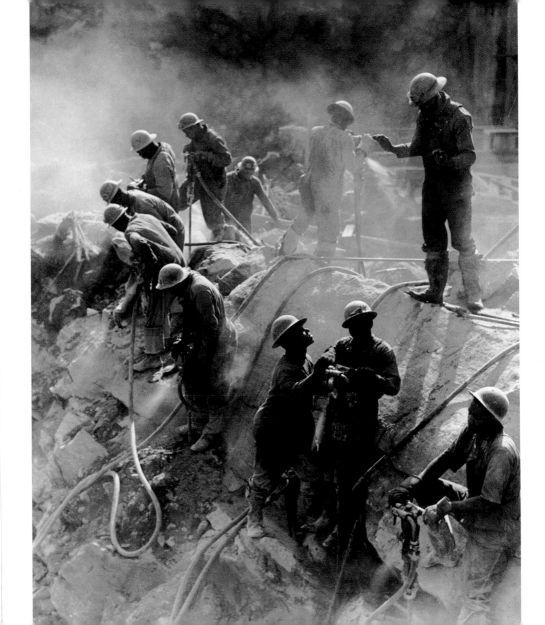

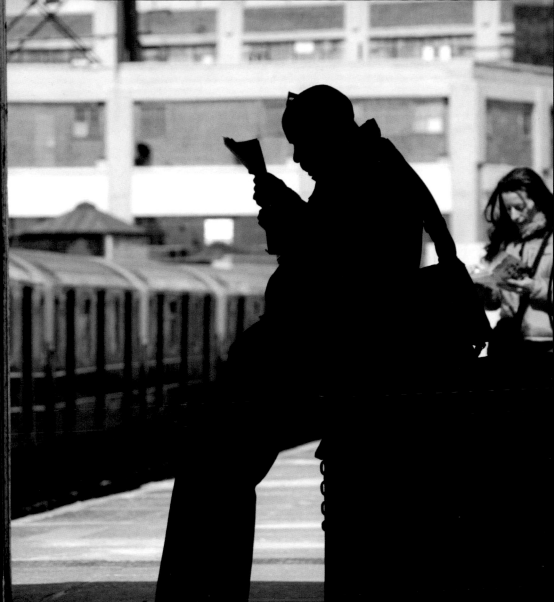

Manufacturing

CHAIRMAN MAO TSE-TUNG'S "GREAT LEAP FORWARD," begun in 1958, was meant to create modern industries, such as steel mills, in China. It did, although many failed to prosper. Real success came to China after Mao's death, when the leadership embraced free-market economic reforms, and manufacturing blossomed. Now the words "Made in China" can be found worldwide on a vast array of goods—toys, textiles, and electronics—produced in the Communist nation.

One of the simple truths of capitalism is that people will manufacture anything they think will sell. Apparently some manufacturer thought there was demand in Shanghai for cigarette lighters with the face of the man known in China as the "Four Greats: Great Teacher, Great Leader, Great Supreme Commander, and Great Helmsman." In Martin Parr's 2003 photo, the lighter on the left calls to mind Mao's "Little Red Book." On the far right, a blonde graces a more contemporary model designed to resemble that current status symbol: the cell phone. Now that's a leap.

MARTIN PARR
How now Chairman Mao? Lighters made in China, Shanghai
2003

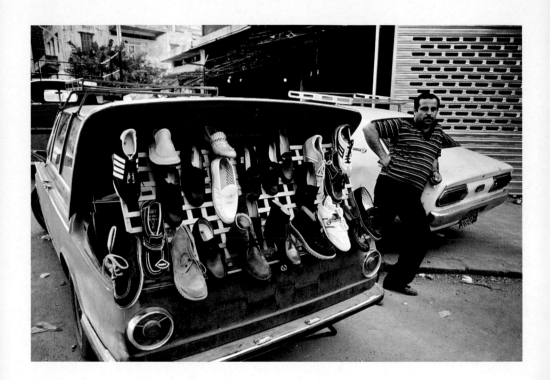

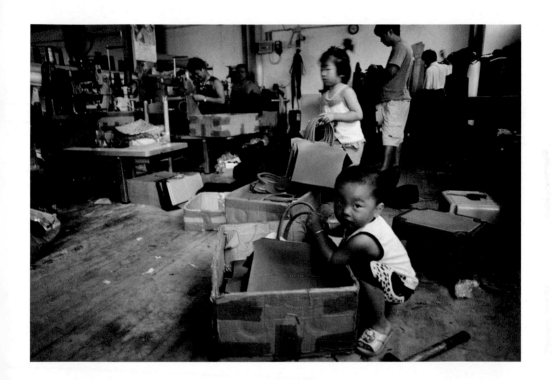

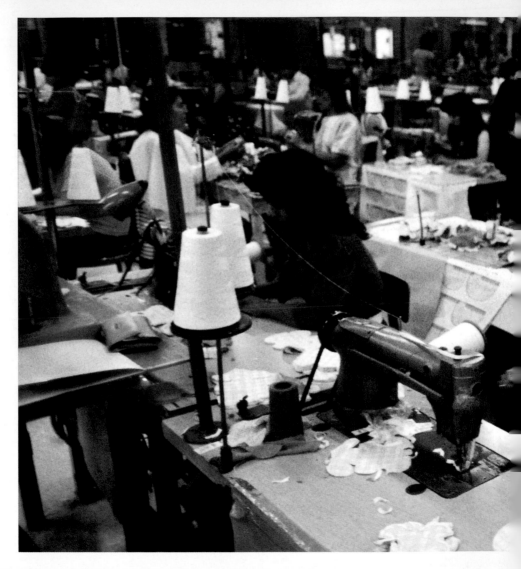

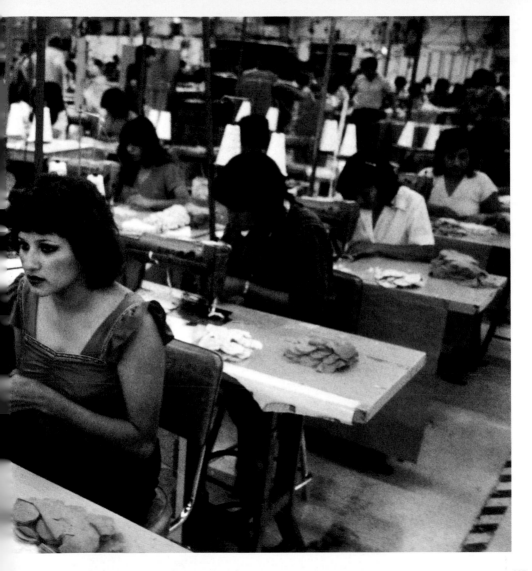

WILL VAN OVERBEEK
Sewing factory, Tamaulipas State, Mexico
1986

JUSTIN GUARIGLIA
Bamboo scaffolding used in Hong Kong's
housing construction, China
2002

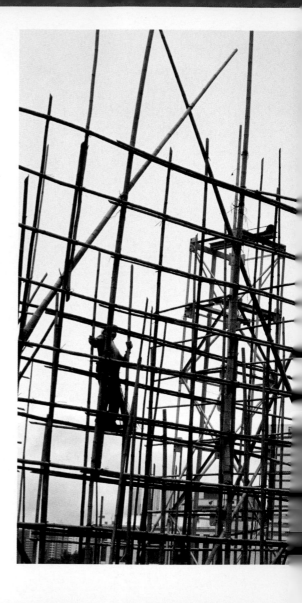

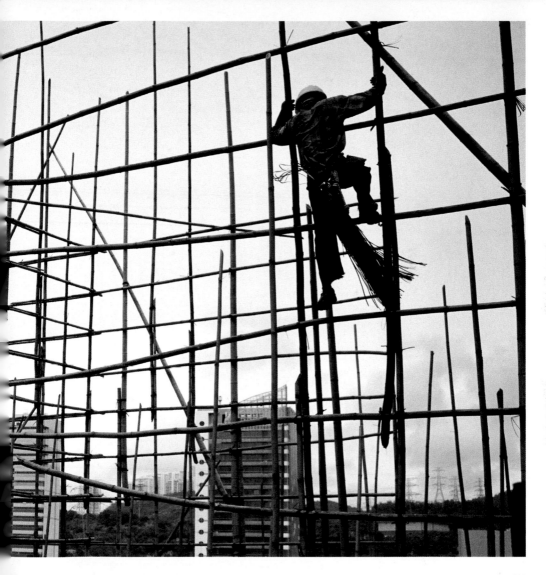

opposite:

DAVID DOUBILET
Oysters being raised to produce pearls, French Polynesia
1996

JOE MCNALLY
Replacing xenon gas lamps on Luxor Hotel, Las Vegas, Nevada
2001

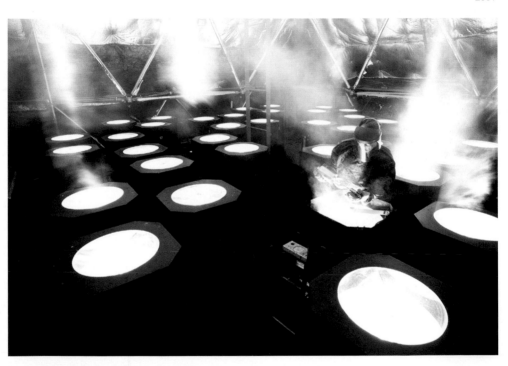

JUSTIN GUARIGLIA
Woman stomping loose tobacco
into wooden box, Yunan, China
2003

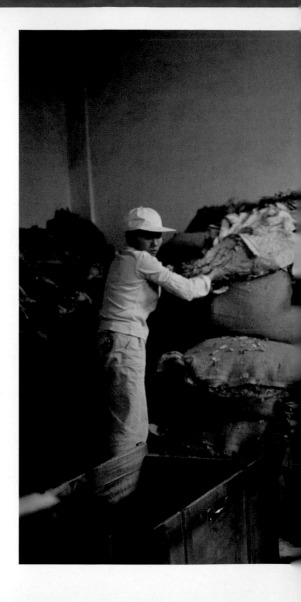

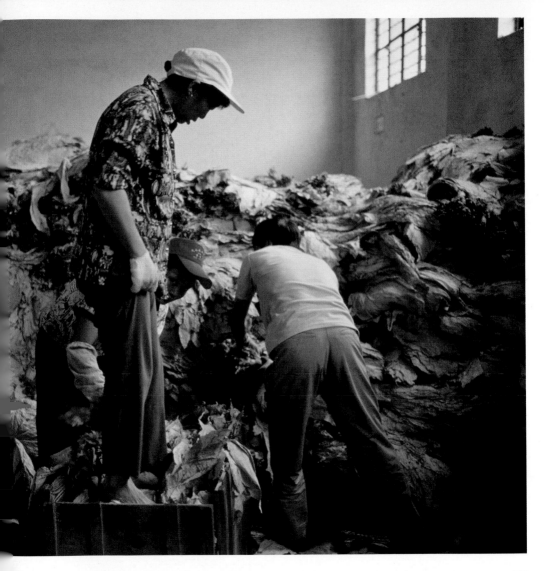

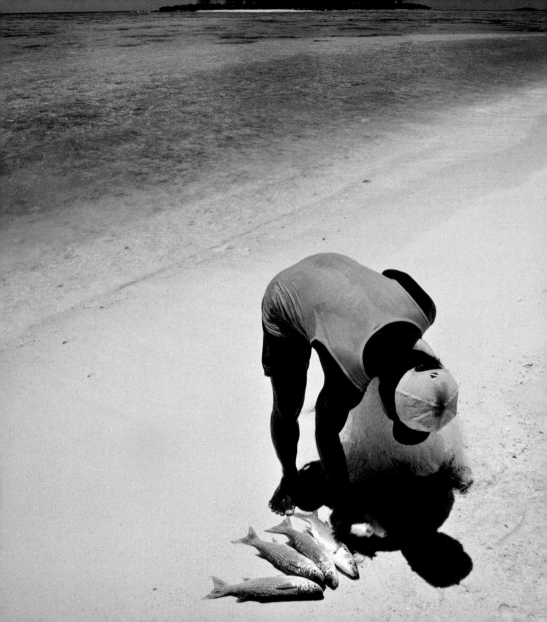

islands

BILL CURTSINGER
Fisherman with catch on Bikini Atoll beach, Marshall Islands
1993

W ork on an island seems like an oxymoron. Manhattan excepted, islands to many people are the place you go to play. The only work involved is traveling to your isle of choice. Once there, life's a beach, all white sand, palm trees, sunny skies, and breezes wafting in from the azure sea.

Islands' romantic allure begins with that sense of separation, of being in a place disconnected from the mainland and the mainstream, beyond the reach of business, bosses, and the cares and labor of ordinary life. It is the idea of escape bordering on abandon and since first entering the mass consciousness with the publication of Daniel Defoe's novel *Robinson Crusoe* in 1719, getting away from it all on an island has become an enduring staple of popular culture around the world. That the notion, like the book, is fiction matters not one whit.

This stereotype of island living, as anyone who has ever read *Robinson Crusoe* can attest, didn't start out as either a choice or a workless existence on an island of ease. Defoe's book, which became the single, most successful novel in the history of Western literature, sings work's praises. The narrative, simple and straightforward, has been interpreted in countless ways by critics of every stripe, including modernist icon James Joyce, who saw Crusoe as the prototypical British colonialist, writing, "the whole Anglo-Saxon spirit is in Crusoe: the manly independence, the unconscious cruelty, the persistence, the slow yet efficient intelligence, the sexual apathy, the calculating taciturnity."

Be that as it may, neither Joyce nor any other critic has suggested Crusoe lacked a work ethic. Defoe was a Puritan. In addition to his novels, he authored guides on how to live a good, Puritan Christian life. While the Protestant ethic had yet to be coined as a phrase, its tenets were central to his beliefs and worldview. Under that ethos, island life and heavenly eternity were reserved for those who worked and prayed hard, not dreamers or idlers.

Robinson Crusoe was shipwrecked. He and his man, Friday, didn't sit around with umbrella drinks watching the waves. They worked like the dickens, gathering food, building shelters and watercraft, and battling adversaries and the elements. When Crusoe, with help from some pirates, is finally delivered after 28 years as a castaway on the uninhabited island, his work and faith are rewarded.

The castaway theme has been reworked countless times since Defoe's day. In most iterations, hard work and faith remain the keys to survival. It wasn't until the television era that the genius of Hollywood writers would turn faith into a metaphor for self-actualization and work would be booted off the island. Those qualities would be personified in a character named Gilligan.

"Gilligan's Island" was a situation comedy that ran on American television from 1964 to 1967. It featured a small band of castaways, passengers who had set out on a "three-hour tour," only to become marooned on a deserted, tropical island in some unnamed ocean. The cast, led by the Skipper, and Gilligan, his first mate, memorably portrayed respectively by Alan Hale, Jr. and Bob Denver, were sometimes shown at work, building various things or hunting and gathering food. But most of their time was spent scheming, dreaming, having slapstick adventures, and, ultimately, learning to tolerate if not respect each other as individuals. Still, work was present.

It wasn't until 1978, when "Fantasy Island," premiered, that island magic completely supplanted Crusoe's work ethic. For six television seasons, guests arrived on a lovely tropical island where a mysterious "Mr. Roarke," played by Ricardo Montalban, who moonlighted as pitchman for the Chrysler Cordoba automobile upholstered in "rich Corinthian leather,"

made their fantasies come true, within the moral parameters of mainstream American taste and sponsors' predilections, of course.

While Mr. Roarke's work was making fantasies come alive, what the show was selling was that time-honored combination of separation and romance, the emotional appeal of the heroic, adventurous, remote, mysterious, and idealized. The main characters were far from home and freed from work. If more tedious tasks were required to provide their fantasies—cooking food, serving drinks, making beds, cleaning bathrooms, conjuring up lost loves—they were done by others off camera. Instead of the existential life of Robinson Crusoe—an atomized individual surviving in a hostile environment by his wits and work—the main characters on "Fantasy Island," were working on self-discovery while enjoying a fabulous island vacation. We should all be so lucky.

In the real world, work never stops. Everyone on the planet works in some sense of the word, even on islands. Defoe was working when he wrote his books. The producers, writers, directors, casts, and crews of every television show set on an island worked long hours. So did the photographers whose pictures are in this book.

Taking photos on a South Pacific island might not strike some people as work. It obviously isn't the toughest gig around, but the images don't appear by magic. They are made by people coping with pressure from deadlines, budgets, and high expectations, their employer's and their own. As Edward Weston once wrote, "photography to the amateur is recreation; to the professional it is work, and hard work, too, no matter how pleasurable it may be."

As we have seen time and again in this book, photographs can make work, even in its most dangerous and noxious forms, look beautiful. That beauty can come from the work being done, from the people doing it, or from the physical setting in which the work takes place. The wonder of photography is that, in the right hands, it can see beauty everywhere, even in the perpetuum mobile of work, and it can stop time long enough to turn that beauty into a picture.

Beautiful does not mean pretty or happy or comfortable. Joel Sartore's photograph at the end of this chapter showing a fisherman standing knee-deep in dead by-catch aboard a trawler off the coast of Canada is an aesthetic masterpiece, referencing visual elements from 17th-century Dutch still-life painting to the eye-seizing color-burst that inspired National Geographic magazine's famous "red-shirt school" of early color photography during the 1950s, when photographers would provide indigenous subjects with a red shirt to liven up the image.

Beyond the beauty, photographs are an interface where our ideas, our fantasies about work and life, meet someone else's visions of reality. What Sartore photographed is horrible, the opposite of the romantic image Paul Chesley captured of a lone individual heading into the sea and sunset in an outrigger canoe. Fishing in Sartore's picture is not a coastal occupation. It is an industrial enterprise in which large ships catch huge quantities of fish in seas thousands of miles from their home ports. Only the fish that fetch a good price in the market are kept. All the other creatures that get swept up in their nets are referred to in the industry as by-catch. This by-catch—small fish, undesirable species and other marine life—usually ends up dead in the bottom of some trawler before it gets flushed back into the sea.

Ignoring that euphemism and looking at Chesley's sunlit image may seem more pleasant and comforting. Any tourist who returned from an island vacation with such a shot would have it blown up, framed, and displayed so family and friends could admire it and dream of lazy days and fish dinners at the beach.

But the fellow in the outrigger canoe isn't on vacation. He's going to work. Lovely as the setting and the boat are, fishing at sea is one of the most dangerous occupations on Earth. Some 38 million people around the world work in fishing and fish farming, about 15 million of them aboard various types of vessels that are less than 24 meters long. The International Labor Organization estimates 24,000 fishermen die worldwide each year, a fatality rate far exceeding the national average for other occupations in most countries.

Danger doesn't appear to be a factor in Bill Curtsinger's photograph of a fisherman laying out his catch on a beach in the Bikini Atoll. The image looks like it came straight from central casting to fill a request for an image of work on an island in paradise. The local weather is certainly appropriate. Air and water temperature in the atoll average between 80 and 85 degrees Fahrenheit year round.

If only life were that simple. Bikini Atoll is part of the Marshall Islands, consisting of 29 atolls and 5 islands scattered over about 70 square miles north of the Equator in the remote reaches of the Pacific Ocean. After World War II, the United States government decided it needed a place to test the effects of atomic bombs on American warships. Bikini Atoll, well off any regular air or sea lanes, was chosen as the site for the tests.

All 167 Bikinians, whose lifestyle and diet were based on lagoon fishing and coconut cultivation, were removed in 1946 to another, less fertile part of the Marshall Islands. Over the next ten years, atomic and hydrogen bomb detonations vaporized three of the atoll's islands—Bokonijien, Aerokojlol, and Nam—and scattered fallout and radiation over the Marshalls and a broad swath of the Pacific. "As soon as the war ended, we located the one spot on Earth that hadn't been touched by the war and blew it to

hell," was comedian Bob Hope's comment on Bikini's fate. One wonders what Daniel Defoe, in his Puritan ardor, would make of the works of man obliterating the works of God?

The good news is that Bikini Atoll did not remain toxic, but eventually healed itself and is now teeming with life, notably the gray reef shark, which belongs to the large family of requiem sharks. However, unacceptably high levels of radiation mean that the atoll cannot be permanently inhabited. The Bikinians still live scattered in the Marshall Islands. Fishing in the lagoon, as in Curtsinger's photo, is allowed only with their permission.

Nuclear bomb tests are an extreme example of how man's work can reshape the planet. A more pastoral vision can be seen in Sam Abell's photograph of gently curving rows in a field of lavender in Tasmania, Australia. With its stormy sky, dramatic lighting, set-piece composition, and soft, limited tonal range, the picture resembles a Claude Lorrain landscape painting.

Clearly, someone had worked the field. The neat rows didn't happen by magic. Toil was required. Yet, no people are in the picture, neither buildings nor machines intrude. As far as we can tell, the only person present at that moment was the man whose eye was pressed to the viewfinder and produced this work of art. Maybe Tasmania, known for having the cleanest air in the world, is the real fantasy island.

While man's work can reshape the planet, the Earth's geophysical features also influence what work is done where. Not all islands are created equal. Nor are they all located in tropical seas or temperate climates. Some, such as Australia, are big enough to merit the name continent. If you want to be a long-distance truck driver in Australia, no problem. Others islands, such as the Marshall Islands, are specks of coral and sand. Long-haul trucker is not a

realistic work choice if you live in the Marshalls or many other islands around the globe. To do that, you either have to find another place to live or another line of work.

Even where there is sufficient space, weather can affect work. In the harsh climate of the Antarctic, there is little demand for swimming pool cleaning or lawn-mowing services.

The Royal Geographic Society's black-and-white photograph of Explorer Earnest Shackleton's star-crossed expedition to the Antarctic in 1914 provides a vivid testimonial to nature's power. After five months and nine days on wind-ravaged Elephant Island, Shackleton and five crew members set off in search of rescue, their boat caulked with lamp wicks, seal blood, and oil paints. Remarkably, they crossed 800 miles of open water to South Georgia Island in that boat and returned to rescue their colleagues without loss of life.

These days, man is a permanent presence in Antarctica. George F. Mobley photographed a worker pulling a sled across the ice sheet to facilities built under a dome at the Amundsen-Scott Station. Managed by the U.S. National Science Foundation, the base sits a fifth of a mile from the South Pole and is getting closer, since the ice on which the station is positioned is literally moving. The U.S. Antarctic research program utilizes some 2,500 people to operate programs dealing with upper atmospheric physics and chemistry, astrophysics, and biology. The continent's relatively pristine skies are also drawing increasing interest from astronomers.

Where nature has the upper hand, humans leave their mark. Nearly 4,000 people from the U.S. and other countries work at research facilities near the South Pole. In addition to scientific reports, they produce tons of garbage and sewage. The work of cleaning up the mess is progressing slowly. We don't see those problems in Mobley's picture, just a guy with a sled in a strangely beautiful place.

Did the worker dragging the sled think there was something special about the scene he was in? Was he trudging along, angry at his boss for not giving him a day off or heading home after a tough shift thinking that taking a job in Antarctica was the stupidest thing he'd ever done? Do the people working in such a place see the beauty the camera catches? Or, like people everywhere, are they usually too busy with their daily tasks and trying to survive to notice?

There is no single answer. Each individual views work and life from their own perspective. Regarding Antarctica, Norwegian explorer Roald Amundsen said, "the land looks like a fairytale." British explorer Robert F. Scott, the British explorer who died in 1912 trying to return after reaching the South Pole, wrote, "Great God! This is an awful place."

The same dichotomy can probably be found everywhere people work. The construction worker building a power plant in the United States may look at the vast grid of reinforcing steel bars and see it as an interplay of lines, light, forms, and shadows. A camel driver posing in front of the Pyramids may understand that the setting gives his life, work, and beast a certain majesty. The fisherman on China's Li River may pause in his poling and gaze at the odd-shaped peaks silhouetted by the sun and think, "Wow, that's beautiful."

Then the moment vanishes. They don't get paid for aesthetic appreciation or to think about the relationship between photographs of work and the act of working. They have to get back to work. Whether your job is an island fantasy or cold reality, life's pages turn quickly in the workplace that is our world. If you're not looking, the book can be closed before you know it.

preceding pages:

DAVID DOUBILET
Diver on tractor dumped into harbor during World War II, Mbanika Island
1987

JODI COBB
Portrait of a young Asaro mudman, Papua New Guinea
1998

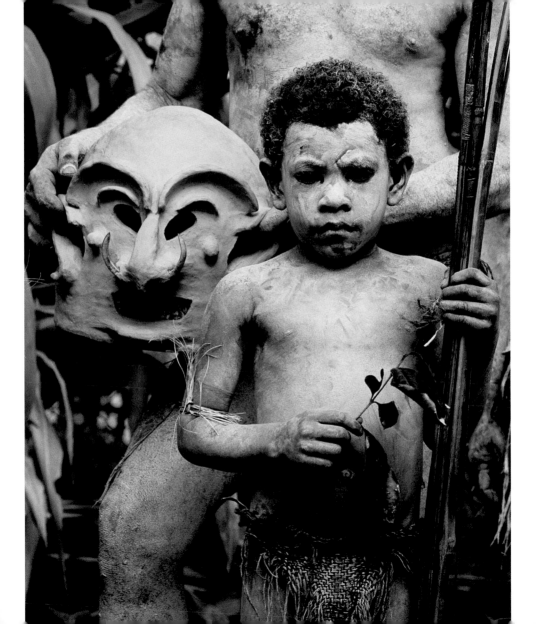

RANDY OLSON
Shark-hunting dogs help control the
shark population on Palmyra
2000

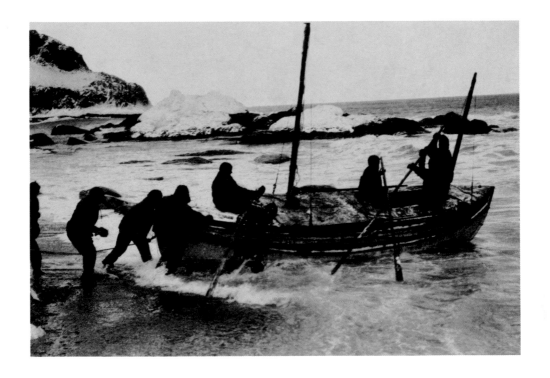

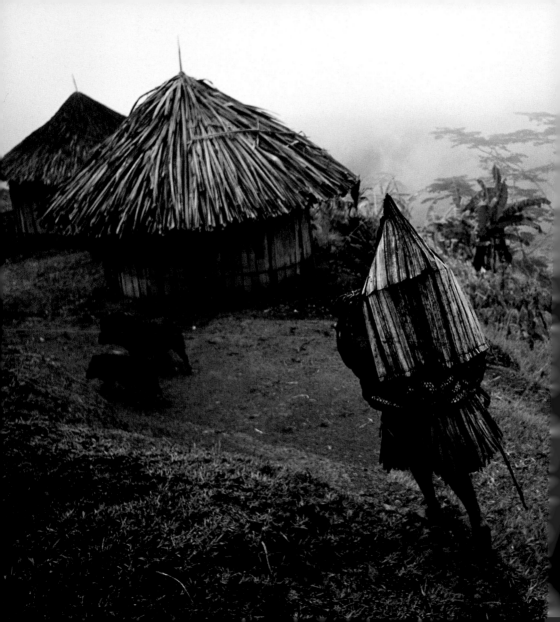

SAM ABELL

Working the land:
rows of lavendar,
Tasmania, Australia
1995

ALEXANDRA BOULAT

Yali woman carrying
home sweet potatoes,
Irian Jaya, Indonesia
2001

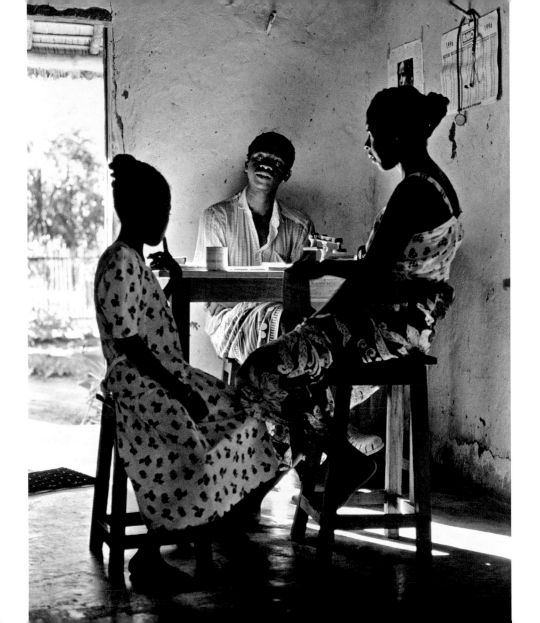

PAUL CHESLEY
Woman displaying black pearls, Tahiti
1994

preceding pages:

JUSTIN GUARIGLIA
Woman carrying basket on head, Bali, Indonesia
2001

GEORGE STEINMETZ
Opening day of Asmat tribe art festival, Irian Jaya, Indonesia
1994

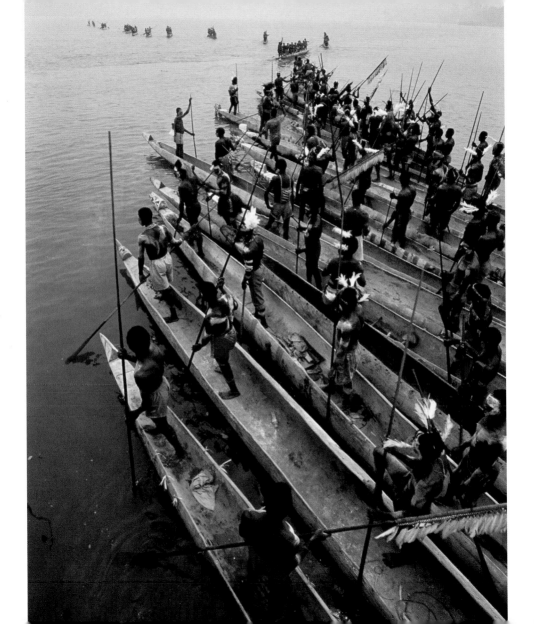

CARY WOLINSKY
Man scrubbing crocodile carcasses before skinning them,
Queensland, Australia
1998

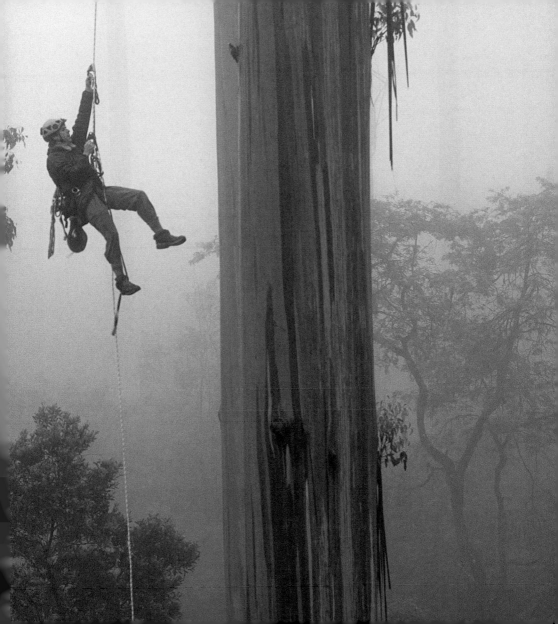

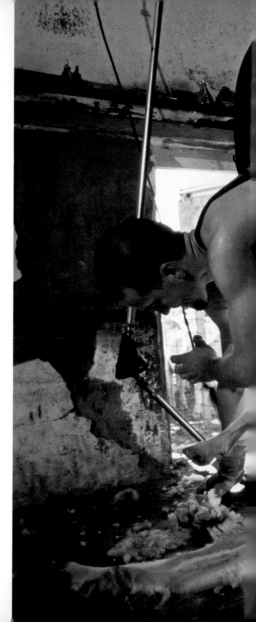

preceding pages:

BILL HATCHER

Surveying ecological health of mountain eucalyptus trees,
Great Dividing Range, Eastern Australia
2002

MEDFORD TAYLOR

Sheep shearing, Mount Lyndhurst Station, South Australia
1996

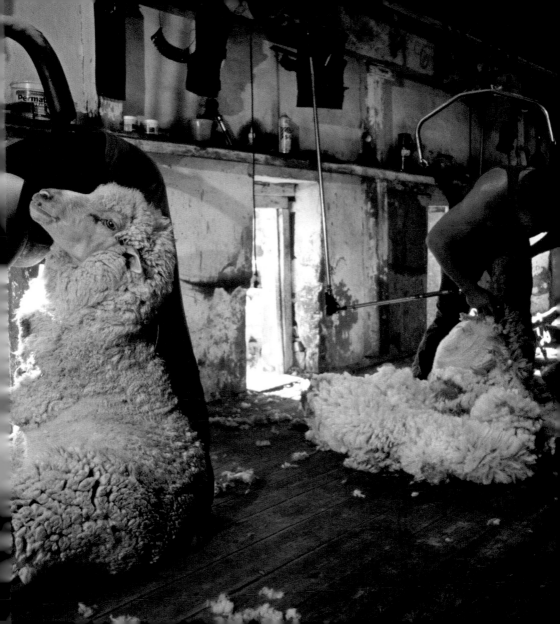

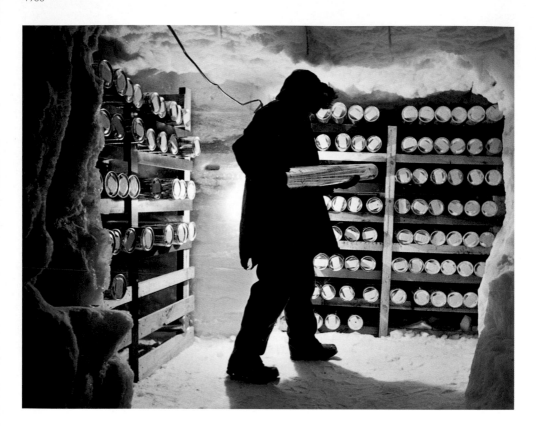

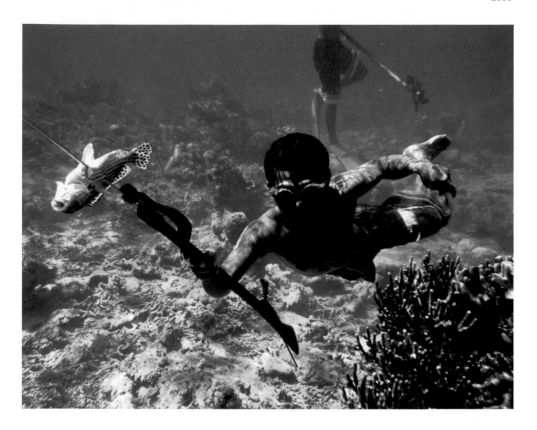

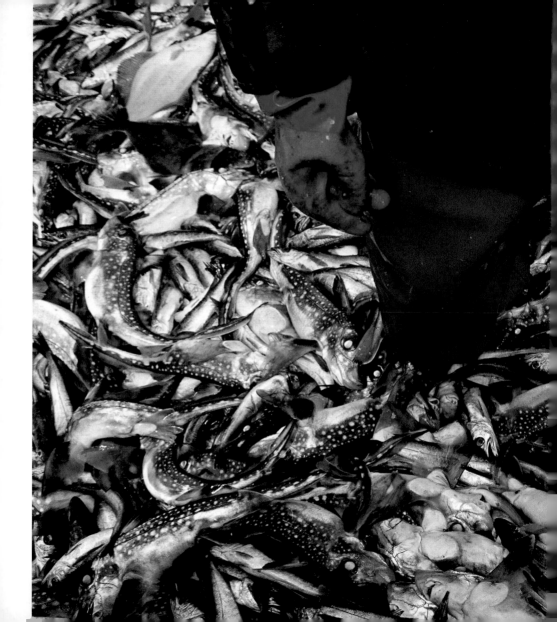

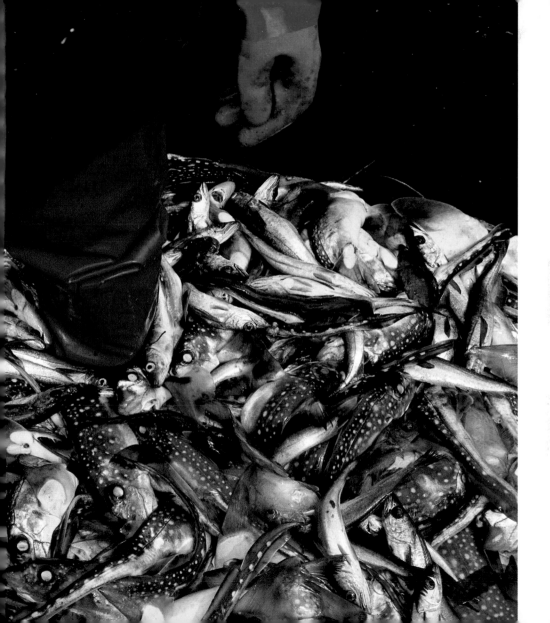

WORK
THE WORLD IN PHOTOGRAPHS
By Ferdinand Protzman

Published by the National Geographic Society
John M. Fahey, Jr., President and Chief Executive Officer
Gilbert M. Grosvenor, Chairman of the Board
Nina D. Hoffman, Executive Vice President;
 President, Book Publishing Group

Prepared by the Book Division
Kevin Mulroy, Senior Vice President and Publisher
Kristin Hanneman, Illustrations Director
Marianne R. Koszorus, Design Director

Barbara Brownell Grogan, Executive Editor
Elizabeth Newhouse, Director of Travel Publishing
Leah Bendavid-Val, Director of Photography Publishing
Carl Mehler, Director of Maps

Staff for this Book
Leah Bendavid-Val, Editor
Rebecca Lescaze, Text Editor
John C. Anderson, Illustrations Editor
Peggy Archambault, Art Director
Dana Chivvis, Associate Illustrations Editor
Anne Moffett, Researcher
Mike Horenstein, Production Project Manager
Teresa Neva Tate, Editorial Illustrations Specialist
Cameron Zotter, Design and Production Assistant
Al Morrow, Production Assistant

Jennifer A. Thornton, Managing Editor
Gary Colbert, Production Director

Manufacturing and Quality Management
Christopher A. Liedel, Chief Financial Officer
Phillip L. Schlosser, Vice President
John T. Dunn, Technical Director
Vincent P. Ryan, Director
Chris Brown, Director
Maryclare Tracy, Manager

The Library of Congress has cataloged the 2006 edition
as follows

Protzman, Ferdinand.
 Work : the world in photographs / Ferdinand Protzman.
 p. cm.
 ISBN 978-0-7922-6204-6
 1. Working class—Portraits. 2. Portrait photography. 3.
Protzman, Ferdinand I. Title.

TR681.W65P76 2006
779'.93317—dc22

 2006040226

Founded in 1888, the National Geographic Society is one of the
largest nonprofit scientific and educational organizations in the
world. It reaches more than 285 million people worldwide each
month through its official journal, NATIONAL GEOGRAPHIC, and its
four other magazines; the National Geographic Channel; televi-
sion documentaries; radio programs; films; books; videos and
DVDs; maps; and interactive media. National Geographic has
funded more than 8,000 scientific research projects and supports
an education program combating geographic illiteracy.

For more information, please call 1-800-NGS LINE (647-5463) or
write to the following address:

National Geographic Society
1145 17th Street N.W.
Washington, D.C. 20036-4688 U.S.A.

Visit us online at www.nationalgeographic.com/books

For information about special discounts for bulk purchases,
please contact National Geographic Books Special Sales: ngspec-
sales@ngs.org

For rights or permissions inquiries, please contact National
Geographic Books Subsidiary Rights: ngbookrights@ngs.org

ISBN: 978-1-4262-0301-5

Printed In China

ACKNOWLEDGMENTS
The editors of *Work* are indebted to the National Geographic
Image Collection, Image Sales, Digital Imaging Lab, and National
Geographic Archives, especially Taranjit Kaur; Brian Drouin; Susie
Riggs; Paula Allen; Lisa Mungovan; Sanjeewa Wickramasekera;
Erika Norteman; Bill Bonner; Charles W. Harr; Betty Behnke; and
David C. Uhl. Additional thanks to Steve Earle; Samek, Hadasa,
and Michal Mokryn; Pat Graves; and John Anderson.

Finally, our appreciation goes to our colleagues in National
Geographic's International Licensing and Alliances, especially
Robert Hernandez, Maeyee Lee, and Rachel Love.

Note on dates: Date of first publication appears with previously
published pictures; date of acquisition appears with unpublished
photographs; when exact dates are unknown, approximate dates
are given.

Ferdinand Protzman is an award-winning cultural writer and critic
and author of the highly acclaimed books *Landscape:
Photographs of Time and Place,* and *Wide Angle: National
Geographic Greatest Places.* His reviews, essays, and articles have
appeared in the *Washington Post,* the *New York Times,* the *Wall
Street Journal,* the *International Herald Tribune, ARTnews,* the
Harvard Review, Forward, and *Zeit-Magazin.* He also wrote the after-
word to Arion Presse's limited edition of *The Voices of Marrakesh,* by
Nobel Prize-winner Elias Canetti.

Pages 20-21, Sebastião Salgado/Amazonas Images/Contact Press Images; 22,
Anonymous/CORBIS; 58-59, George Steinmetz/CORBIS; 82-83, Jack Delano/courtesy
Library of Congress; 96-97, Henri Cartier-Bresson/Magnum Photos; 118-119, Gueorgui
Pinkhassov/Magnum Photos; 120, Ian Berry/Magnum Photos; 195, Ian Berry/Magnum
Photos; 252-253, Arthur Rothstein/courtesy Library of Congress; 255, Jack Delano/cour-
tesy Library of Congress; 259, Marion Post Wolcott/courtesy Library of Congress; 267,
Edward S. Curtis/courtesy Library of Congress; 268-269, Mario Tama/Getty Images; 280,
Lewis Wickes Hine/courtesy Library of Congress; 281, Lewis Wickes Hine/CORBIS; 290-
291, Joe Raedle/Getty Images; 297, Jack Delano/courtesy Library of Congress; 298, Jack
Delano/courtesy Library of Congress; 300-301, Mario Tama/Getty Images; 302-303,
Martin Parr/Magnum Photos.